P9-CBT-959

WITHDRAWN

261885602

FRAME OF MIND
VIEWPOINTS ON PHOTOGRAPHY IN
CONTEMPORARY CANADIAN ART

Walter Phillips Gallery
The Banff Centre for the Arts
Box 1020–14
Banff, Alberta
Canada ToL oCo

The Banff Centre
for the Arts

Published with support from the Canada Council Visual Arts Section
Assistance to Public Galleries and Museums program

© 1993 Walter Phillips Gallery, authors and artists
All rights reserved
Printed in Canada

Design: Charles Cousins
Coordination and Editing: Mary Anne Moser
Printing: Paperworks Press, a division of Sundog Printing Limited

Canadian Cataloguing in Publication Data

Main entry under title:
Frame of Mind

Includes bibliographic references.
ISBN 0-920159-54-0

1. Art and photography–Canada. 2. Photography, Artistic–Canada.
3. Art, Modern–20th century. I. Augaitis, Daina. II. Walter Phillips Gallery.
TR642.F72 1993 770'.92 C93-091109-1
Cover and Jacket: Evergon, N I G H T W A T C H (detail),
Dominique Blain, S T A R S A N D S T R I P S (detail).
Photo: Don Lee and Cheryl Bellows.

Frame of Mind

VIEWPOINTS ON PHOTOGRAPHY IN CONTEMPORARY CANADIAN ART

Edited by **Daina Augaitis**

Introduction by **Charlotte Townsend-Gault**

Shelagh Alexander **James D. Campbell**
Raymonde April **Richard Baillargeon**
Roy Arden **Serge Bérard**
Dominique Blain **Johanne Lamoureux**
Kati Campbell **Donna Zapf**
Evergon **Alain Laframboise**
Mark Lewis **Abigail Solomon-Godeau**
Susan McEachern **Cheryl Simon**
Susan Schelle **Ian Carr-Harris**
Ian Wallace **Scott Watson**

WALTER PHILLIPS GALLERY

CONT

Acknowledgements

The artworks in this publication, now in the Banff Centre's permanent collection at the Walter Phillips Gallery, are selected from a vast range of practices worthy of study, support and attention. The acquisition of these particular works and this subsequent publication have been made possible through the contributions of many individuals who have been involved over the past few years.

To the artists who generously showed their works and made them available for the collection, we owe the deepest thanks. The members of the acquisitions committee, some of whom have come or gone over the course of the project, have all contributed time and thoughtful consideration to the purchases: Neil Armstrong, Richard Baillargeon, Lorne Falk, Sylvie Gilbert, Les Manning, Helga Pakasaar, Dan Thorburn, Brenda Wallace and the late Paul Fleck. During her tenure as associate curator at the gallery, Helga Pakasaar was responsible for much of the impetus behind the acquisitions research and curator Sylvie Gilbert has seen this project to its completion. Their curatorial energies have played a central role in bringing these works to the collection and their assistance to me has been enormous. Working with them, gallery staff spent many hours showing professional responsibility for the works. Preparators Leslie Sampson, Reid Weir, Garth Cantrill and Mimmo Maiolo, and gallery technician Sally Garen have been instrumental, as have Michael Toppings and Mary Squario. Registrar Deborah Cameron handled important arrangements concerning the artworks.

All of the writers commissioned to prepare essays for this book have provided thoughtful texts that cover a range of issues raised by contemporary photo-based art today. Charlotte Townsend-Gault has written a comprehensive introduction that serves an important role in assessing the links and relevance of photographic artwork in Canada. Mary Anne Moser, publications editor, has done an admirable job of

coordinating and editing the publication, assisted in photo research by Colin Griffiths and in proofreading by Vivian Elias, Mary Squario and the communications department at the Centre. Wendy Robinson, visual arts secretary, and her assistant, Tina Fields, have helped with much of the typesetting and Pauline Martin, assistant manager, has contributed budgeting expertise. The many photographs in this book have been provided by a range of sources, to whom we are thankful, especially Monte Greenshields and Cheryl Bellows, who are responsible for the colour photography of the acquisitions.

Most importantly, this publication has been financed through the Assistance to Public Galleries and Museums program of the Canada Council Visual Arts Section and we are very grateful for this support. Steve Whitehall provided a generous donation to this project, in addition to ongoing professional advice and encouragement in his role as president of Paperworks Press and later as vice-president, sales, at Sundog Printing Limited. Designer Charles Cousins took up this challenge with admirable care and enthusiasm and has created a book that presents some important works in the development of photographic art practice in Canada.

D.A.

Foreword

Photographic representation has profoundly affected what we see and how we understand our worlds. Through electronic technologies and mass media in particular, the photographic image – in its original and manipulated states – has become a dominant form of communication. It is not surprising then that many artists have taken it up as a significant tool for artistic practice, often to comment on powerful spheres of representation.

Although photo-based art has been developing in the last three decades, it did not become prominent in Canadian art practice until the eighties. In 1988, as a recognition of this status, the Walter Phillips Gallery began an acquisitions project to represent this practice in the Banff Centre's permanent collection. The ten artworks acquired over a period of several years are but a few examples of a range of hybrid activities that embrace the representational aspects of photography within art's many discourses. This selection includes work by Shelagh Alexander, Raymonde April, Roy Arden, Dominique Blain, Kati Campbell, Evergon, Mark Lewis, Susan McEachern, Susan Schelle and Ian Wallace – a cross-section of Canadian artists who span several generations and have gained visibility in Canada and abroad.

Although these works reflect many strategies, they share a conceptual basis, replete with references to the larger social body with all of its paradoxes and complexities. The works also address broader contemporary art issues related to the politics of representation such as the construction of history, gender, and public and private identity. Strategies include image and text relationships, narrative sequencing and the incorporation of images as original or found, manipulated or pristine, inscribed with words and other media.

In addition to the timeliness of photo-based work, another inspiration for this project was to present a counterpoint to a body of photography already present in the Centre's

permanent collection. Acquired through the Banff Purchase in 1979, the existing material includes 153 photographs, primarily black and white – many of them made in the documentary tradition that was prominent in western Canada in the 1970s – by Charles Gagnon, Nina Raginsky, Orest Semchishen, Tom Gibson, David McMillan, Robert Bourdeau and Lynne Cohen. Just as documentary photography was the precursor of much contemporary photographic art practice, the Banff Purchase of the late seventies was the forerunner of this new acquisitions project. However, the work represented here extends beyond the reality-defining goals of documentary work. The artists discussed in this publication investigate concerns specifically related to the photograph and extend the language of the medium by positioning photographs within a larger framework. Epistemological skepticism, kindled by the critique of representation that has become significant in many academic, political and artistic realms, has opened up new areas of practice and critique of form and content. Whether it is the photographer's eye that is acknowledged as the mediating lens of subjectivity or whether the complex representation of the social context is approached, these works draw attention to the cultural constructions that create our readings of images according to established codes, conventions and languages. The power inherent in different contexts is often subtle; many artists working with photography have chosen to examine and disrupt that authority.

This publication begins as a document of new acquisitions, but it is much more than that. In a discerning essay by Charlotte Townsend-Gault, many historical antecedents to the works in the recent acquisitions are examined. She connects some of the important directions and innovations in contemporary photo-based art over the past twenty-five years with works in this collection. Then, in greater detail, individual artists and critics offer interpretive views on each of the artists and their practices. The resulting publication not only stands as a document of a permanent collection but offers important examples of Canadian art practice at a critical time in the history of photography.

Daina Augaitis

Wavelength to Patternity:
Epistemology with a Camera

Charlotte Townsend-Gault

> This essay is in memory of my father, William Townsend, Professor at the Slade School, London, who also painted and taught regularly at the Banff Centre from 1951 until his death there in 1973.

It is a current truism that the meanings of photographs are made in the course of discourse and that when the discourse shifts, the photographs mean something different; they look different. Not surprisingly then, over the past twenty-five years in Canada, there has been no one discursive line; individuals implicated in different discourses see meanings and values differently. To be effective, *ex cathedra* statements from *les decideurs*[1] must be able to depend on a command economy of the sign or something like a reliable, and near universal, consensus on the significance of images. However, that, for all the institutionalization of our culture, we do not have.

In a period when the forces of modernity have been both contested and extended, the authority of these discourses emanates from recombinant sources in philosophy, psychoanalysis and hybrid modes such as feminism, cultural theory and anthropology. Although this is not the place for a history of these discourses, it is not the place for rhetorical generalizations either. However, one common characteristic might be considered – the question informing the discourse of photography has concerned epistemology: how do we know what we know? This leads to: how do we represent

what we know to ourselves, to others, and what part do the representations themselves play in the knowing? Provisional answers to these portentous questions demonstrate that the tendency in photographic discourse has been to collapse, invert, interrogate again.

To describe this situation as one of open-ended diversity is to make use of one of the flabbier definitions of pluralism, which does not do justice to regional specificity nor to the evident existence of hierarchies of power and knowledge. It seems more appropriate to look at particular photographs for what they reveal of the discourses. When considering the accumulation of images that have in one way or another made a difference in photo-based art practices in Canada since about 1967, certain photographs seem to recur. I have chosen them not because they are milestones or prototypes, not because they have been influential (although some of them have been) and not because they constitute a chronology. They could be called exemplars of the range of art practices that have been apparent since the late sixties. The concerns of the eight works discussed here are sometimes overlapping, sometimes conflicting, but they are indicative of significant aspects of the discourse of photography over the past quarter century in Canada.

ENQUIRY INTO THE CONNECTIONS BETWEEN THE SHAPE OF VISUAL KNOWLEDGE AND THE TECHNICAL POSSIBILITIES AND LIMITATIONS OF THE CAMERA: *WAVELENGTH* (1966–67)

Michael Snow's use of the camera in the production of *Wavelength* sets up an agenda that questions the requirements for a rational enquiry into the shape of visual knowledge. It asks whether what the camera does – the zoom, pan, focus, close-up and fade – is simply technological and therefore arbitrary or whether it reflects in some way the underlying structures of vision. *Wavelength* is, in this sense, the precursor of camera-driven epistemology in Canada.

Wavelength imposes onto a still photograph of waves a forty-five minute zoom through a sparsely furnished studio that is occasionally invaded by some human action. It is exemplary in its pursuit of the logic of the gaze, the moving gaze that ultimately must settle and focus on something still. The logic in question is understood to be a structural logic insofar as the gaze is implicated in the structural opposition between moving image and still.

The camera could be a tool with which to measure the determining parameters of vision, to measure how the camera frames what we see. In 1966 it could have been argued that photographers had been doing nothing else since Niepce. However, Snow was responding to the contemporary interest in structuralism which suggested that by laying bare the elementary structures of the object of enquiry some explanation could be offered for the way things were.[2] Sets of structurally determined oppositions, as they interrelated, resulted in transformations. *Wavelength* works like this: its slow zoom ends on a still; it proceeds through "culture" represented by the tall, elegant, nineteenth-century, eastern North American windows of the kind associated with commercial space turned loft, studio, gallery, and the non-descript furnishings, to the structural opposite of culture – that is, nature – the waves. Its movement proceeds through a still space to a still photograph of perpetual movement. The explicit form of this work is cut with implicit narrative which in turn injects a sense of urgency where none was before, where things may be out of control and the viewer is enraptured by a controlling seduction.

These structural oppositions deliver to us a photograph of a void that is a void, a cultural monochrome of a natural monochrome, the ocean, and thus to the discourse of the monochrome as either sublime or critical.[3] The photograph of waves, classically a sublime subject, is both dense and low on information. This work is an implied critique of the superfluity of images that have been used up, worn out, become redundant, entropic.

Although a formalist, Snow was not a minimalist, unless minimalism is defined as inherently dramatic. The elegance of Snow's work is inseparable from its humour, for his is the kind of comedy that depends on perfect timing. He has isolated the most

seductive formal properties of moving/still imagery by the medium on its most visceral level. It is scopophilia without a subject.

THE SEARCH FOR WAYS OF RECORDING THE ORDINARY TO SHOW THAT IT IS, IN FACT, EXTRAORDINARY, IN WHICH THE CAMERA IS DEPLOYED AS IF IT WERE THE ARTLESS EXTENSION OF AN INNOCENT EYE, WITH THE RESULTING IMAGES UNMEDIATED AND UNDIFFERENTIATED:
PORTFOLIO OF PILES (1 9 6 8)

The leaves of *Portfolio of Piles* have a tendency to slither out of their pile and to fall apart in your hands, forcing you to come to grips with the phenomenology of a pile of photographs of piles of stuff: used tires, lumber, old clothes. The form of the work mimics its content. The idea of a book as something in which one might expect to bring a certain kind of close attention to photographs of visual events is here disassembled and replaced with the idea of a portfolio appropriated from the corporate world. The N.E. Thing Company itself, the artist Iain Baxter and his wife Ingrid as co-presidents, had come into being as a tribute to what was understood as the efficacy of the corporate world and employed its tactics of using billboards, sequential highway signs, back-lit transparencies and a panoply of other communications strategems. In the interests of that realm of activity dubbed communication, and realizing that language was key, the company blended terminology from the art and business worlds to rearrange its categories. What the company wished to communicate was VSI or Visual Sensitivity Information.

McLuhan's analysis, following Innis, served to set the fine arts in a wider context of visual communications.[4] At this point in its history the N.E. Thing Company was exemplary of a time of technological optimism, in which the artists associated with Intermedia, a loose affiliation of multimedia artists in Vancouver which Baxter had helped to set up, shared a faith in the possibility of a society-wide perceptual explosion: enlightenment for all. Art was to be inseparable from the mass media, part of a

communications network. "Art into life," a rallying cry of the Russian revolutionary avant-garde, might have been appropriate had these ideas not been steadfastly de-politicized.

The banality of the visual phenomena that the N.E. Thing Company wished to communicate was a reprimand about overlooking the obvious. An admirer of Duchamp, and using what might be called perceptual ready-mades, Baxter's work was a critique of perceptual boundaries using only perceptual strategies.[5] He was not concerned with the politics of agriculture, land use, the dumping of waste, resource management or other endeavours that lead to the piling up of stuff. Part of the satisfactory resolution of *Portfolio of Piles* is that the concept of piling turned out to be a metonym for something fundamental to the organization of the perceived universe, natural and cultural.

The dematerialized art object of the late 1960s tended to coalesce as a photograph. The possibility, or delusion, of the straightforward presentation of information can be seen in projects designed for the Nova Scotia College of Art and Design projects class by Michael Heizer, Lawrence Weiner, Robert Barry and others. This class had a formative influence on conceptual art in Canada, and many of the projects ended up as photographs notable, in retrospect, for their ambiguity rather than clarity. The photograph of a pile has arguably survived more successfully as information than as shaping concept, due perhaps to Baxter's dogged empiricism.

Portfolio of Piles was a determined attempt to intervene in the categorization, and hierarchical organization, of visual knowledge. It did not so much displace the role that painting and sculpture have played in the categorization of visual knowledge as argue with it. *Portfolio of Piles* can claim exemplary status as a reminder of the obscure charm, and limited reach, of middle-class reforming zeal in matters perceptual. Still, at a time when the matter has received much academic attention, it poses with some poignancy the question as to whether art is a special kind of perception or perception a special kind of art.[6]

Some such enquiry lay behind the early work by other Vancouver artists such as Jeff Wall, for example in *Landscape Manual* (1969) and Ian Wallace in *Poverty* (1982). In the

1990s the staged photographs of Wall's mature work make explicit the subterfuge, and show, with some irony, that the eye never was, and could never be, artless.

THE PHOTOGRAPHIC INSCRIPTION OF HISTORY AND ITS DECONSTRUCTION IN BOTH ROMANTIC AND SOCIAL SCIENTIFIC MODES:
FRAGMENTS... LA MAISON DE RIVIÈRES-DES-PRAIRIES (1 9 7 7)

Scavenging through the neglect, decay and destruction of the built environment, Melvin Charney sees buildings in two ways: as façades and as cultural facts. As a result his work is exemplary of a discourse that was arguably introduced to Canada by Dan Graham through works such as *Homes for America* (1967) in which straight photographs pose as facts. But objective facts are in doubt and photographs are not factual – both propositions that gained new currency in the protean discourse of deconstruction. Rather than responding with *fin de siècle* melancholy, Charney carries out a sporadic local ethnology of cultural forms. First cataloguing them, full frontal photographs of buildings in this case, he then brings in history and economics – comparative material to work on their interpretation.

In *La Maison de Rivières-des-Prairies,* taken from the *Fragments* series (1975–76), Charney made a facsimile of the original photograph in order to distance himself from what were perceived as factual problems of photographs that claimed to document human activity. He was then in a better position to ask questions not so much about the human as the social forces responsible for them: how did that house get there? Why does it look the way it does? Why was it not maintained? Why is it striking now?

Such questions are sometimes posed by the artist in accompanying texts but more often through interventions into or onto the photograph by the artist's hand. Colouring or scratching away at the surface of the photograph, or a replica of the photograph, prevents them from being ignored and from being taken up as neat *trouvailles* of the

urban fabric. Charney's own facture both exposes the construction process and hastens its decay; decay is a form of deconstruction. Clearly these structures have an ideological as well as an architectural pedigree. Are the widely disseminated elements of Graeco-Roman architecture simply tokens of the repetitious theme of colonial abjection or does it represent some cultural awareness in a sea of unknowing? Is the boarded-up house at Rivières-des-Prairies a demotic form of classically derived proportions, a form of disingenuous abuse or is it merely proto-postmodernism?

Rosemary Donegan's recovery of the socio-economic history of Spadina Avenue in Toronto through its architecture (1984), Allen Sekula's *Geography Lessons, Canadian Notes* (1986) and Robert Moore's investigation of the ruins of a former United States Air Force base in Newfoundland, *Harmon* (1987), are also inseparable from analyses of the economic forces at work in the lives of their protagonists. Geoffrey James has a deceptively quiet approach to the remembrance of gardens past that frame the architecture of Europe's aristocracies. What these works share, as they recall old photographs from oblivion and photographically reconstruct ruined architectural contexts or deconstruct decayed buildings, is their critical scrutiny of the social fabric through an interrogation of its façades.[7]

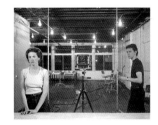

**READING PICTURES
AND THE
HISTORICAL
DRAMA OF THE POINT
OF VIEW:
*PICTURE FOR WOMEN*** (1 9 7 9)

Jeff Wall's *Picture for Women* (1979) stands as an exemplar of the argument with art history that fastidiously, and at length, queries the conventions of perception. Wall has always lived and worked in Vancouver, contributing importantly to the photo-conceptualism associated with that city, which has been informed by an art-historical take on the socio-aesthetic of the Frankfurt School, in particular that of Theodor Adorno.

This work scrutinizes that part of the convention which vests the authority of modernism in the controlling male gaze, inescapable in a canonical work such as Manet's *Un bar aux Folies-Bergères* (1881–82). It also, quite literally, looks at the dependency of photography on the conventions of painting, suggesting that it is not the dependency of a parasite so much as the pursuit of the same mode of enquiry, through the mediation of photography. This relationship is seen again in Evergon's work where dependency on the style of composition of, amongst others, Caravaggio allows them to be exposed and, often, reasserted.

Dependent, like Ian Wallace's *Poverty,* on art historical literacy, there is an expository, even didactic, tenor to Wall's work, informed both by a belief in the efficacy of rational enquiry and what Robert Linsley has called a "faith in the infinite readability of pictures."[8]

In *Picture for Women* the man/artist only appears to be in the background. In fact he is in control – of the pose, the gaze, the woman, and the crypto-eroticism implicit in the *mise en scène.* Mark Lewis' treatment of similar issues grounds his enquiry in the contemporary populist persistence of visual control. Implicit in Wall's reading of Manet is the short distance between the way the woman is looked at and the role she is expected to play. It is made explicit in Kati Campbell's *generic.*

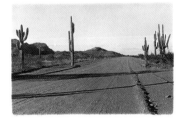 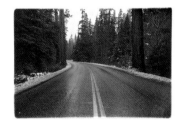

THE PLACE OF MEMORY, AND ITS DESIRES, IN INTERPRETING THE PERCEPTION OF THE WORLD: *REMINDER #3* (1978)

LEFT: VULTURE MOUNTAIN ROAD, NEAR WICKENBURG, ARIZONA
RIGHT: MACMILLAN PARK, NEAR PORT ALBERNI, BRITISH COLUMBIA
A road curving around organ pipe cacti in Arizona had lodged in his mind's eye and predisposed his response to the curves of the road and natural verticals found in British

Columbia. This is but one pair taken from a series that Stan Denniston published in book form as *Reminders.*[9] They exemplify a renewed interest in the determinants, the limits, on the freedom of the individual human eye as subject and, in this case, specifically a remembering subject.

Analyses based on geographical stereotyping or phallic imagery are left to others. Desire and fantasy seem to have been displaced by these sets of images which, banal and mechanistic as they are, short-circuit the delicacy of the Proustian mnemonic. But then, with a camera, who needs Proust? Who needs memory? This work is undoubtedly about memory and its role in the shaping of knowledge, in this case the acquisition of new knowledge by an individual. It thus connects with the work of a photographer like Raymonde April who uses her own store of photographs as an *aide-memoire,* scrutinizing them, as Barthes does in *Camera Lucida,* for traces of information about her responses, a way of accumulating (self-) knowledge.

But *Reminders* is also about form. It has been argued that it is in the differences rather than the similarities of these images that the saving difference between the human eye and the camera can be found. It is, however, driven by a formalist poetics and shows how far that can be instrumental in understanding the observed world. Amongst other works using the camera in this way are Roy Kiyooka's *Stoned Gloves* (1969–70), the formations of photographed faces assembled by Arnaud Maggs to cover entire walls, or Glen Lewis' arrangements of the formalist regularities and idiosyncrasies in national gardening traditions around the world (1977 and continuing). Purposely drained of meaning, the formal resemblances are the substance of these works.

THE INDIVIDUAL VOICE AND THE INDIVIDUAL FACE OR PHOTOGRAPHIC REPRESENTATION AS IT CONTRIBUTES TO THE PRESENCE, OR ABSENCE, OF INDIVIDUALS IN THE CONSTRUCTION OF HISTORY: *SOME FINE WOMEN – PORTIA WHITE* (1983)

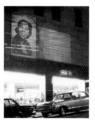

The larger-than-life face of Portia White, herself an exemplar, is projected at night onto the cement block wall of a Zellers store in downtown Halifax. She is one of forty women who have made or are making important contributions to public life in Nova Scotia, whose faces and synopsized achievements, feminist artist Wilma Needham was aiming to reinstate, in public.

This work belongs to a widespread movement to retrieve women from the oblivion to which patriarchal history would consign them. The aesthetic strategy neatly exemplifies the concern with positioning, physical positioning which is revealed as inseparable from social and historical positioning. It is a site-specific strategy recalling but not eclipsed by the nocturnal projections of Krzysztof Wodiczko. Needham's studio overlooked Zellers, a store which caters to homemaker-women, those on a limited budget, as the poses and settings of its window displays make abundantly clear. Her emblems condense an ideology. These reparations are made on a large scale, approximately ten by fourteen feet when projected. Consumerist expectations are aroused by the spectacle of a woman's face to be looked at on a street and this is a deliberate intervention into the outer world of public manipulative, and manipulated, imagery.

The empiricism of Nova Scotia College of Art and Design conceptualism submitted to a sort of truth or dare testing by feminism. Susan McEachern's *On Living at Home* (1987), which blends the theories of both, is a later manifestation of the encounter. Needham's work examines local specifics in an attempt to avoid universalizing formulations, which, either positivist or idealist, tend to be anathema to the women's movement. *Some Fine Women* seeks to substitute the local and personal for what is seen as the hegemony and privilege of the avant-garde.

The accumulation acquires a voice, enters the language. To name is to empower. The image of a person is understood here as a form of naming. Naming the hitherto anonymous is the first stage in the empowerment of finding their own voices. The name of the mother is here inscribed by the process of representing them and their achievements. It is also about the process of marginalization – Nova Scotia is as good at marginalizing its own margins as the most cosmopolitan centre. Unsurprisingly, the white bourgeoisie was better documented than women from the black, native or Acadian communities of the province.

One can also see *Some Fine Women* as exemplary of the co-opting of the non-high art status of photography to critique the positioning of artists and their social roles. In *It's Still Privileged Art* (1976) Carol Conde and Karl Beveridge produced a photo-narrative of their day, showing how its inevitabilities unfolded from their domestic responsibilities and over-determined relationships with dealer and collector, earnestly debated good intentions notwithstanding.

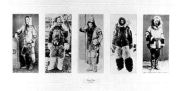

THE PHOTO-DECONSTRUCTION OF COLONIALISM OR THE IMBALANCE OF POWER AND PERSPECTIVE WHICH PHOTOGRAPHY HAD HELPED TO CREATE:
FRANZ BOAS AND OTHERS (1991)

Liz Magor understands how photographs – as you come upon them in time, not as you take them in the present – index a specific historical discourse. She used her own as talismans for the back-to-the-land romance of the 1960s and its curious alliance with Edward Curtis' romantic representation of "vanishing Indians," in *Fieldwork* (1989). Her works are moments of resolution in the traumatic deconstruction of colonialism, a process to which Roy Arden's *Mission* (1985) and *West* (1988) also contribute. Hermenegilde Chiasson's photo-analysis of the predicament of the Acadian artist/intellectual, and Greg Staats' photographs that move away from the long history of dealing with First Nations as documentary material, also contribute to this deconstruction. This, however, is a discourse in which aesthetic resolution itself is questioned as a major delusion.

Franz Boas and Others is a rich, and bleak, condensation of cultural difference and the historiography debate; the title provides the only text. Franz Boas, the linguist and anthropologist, is here cast as the paradigmatic other, who takes his Europeanness, uninvited, to the Arctic and leaves with a set of determining fictions for consumption elsewhere. The signifier in this work, then, is Caucasian male in Inuit parka. Several

signifieds have been brought together through the economical arrangement of multiple signifiers – a series of others who are going native. One man's self-delusion is evidently much like the next; going native doesn't disguise anything, least of all an intruder.

An elegant aesthetic skewers the deadly contradictions of imperialism. The found images have been cropped to the same dimensions and individually mounted, while the frame with its crackle varnish and crossed corners is a pastiche of late nineteenth-century style that offers a different approach to cultural capital. The men and their various ploys are reduced to the same dimensions; the focus is on the common denominator of their dress, so that viewers are aware only that these men are Europeans in non-European body covering. On this cultural stage only two signs are needed: ethnicity and dress – and you have a drama.

There is a heroic cast to these individuals as they prepare to do battle with the elements. In relation to what are they heroic? In relation to the photographer, to other people, to the elements? However, *Franz Boas and Others* is not in the interrogative mode, it does not ask whether these intruders might not also have been helpers, or at least dispassionate seekers after the truth – cultural, geological or meteorological, for example. It does not ask whether we protest too much, imitation being the sincerest form of flattery, and it being only sensible to dress in the warmest available gear. We are deprived of the information that would feed a liberal debate. These photographs are presented in such a way that the men are protagonists in another discourse.

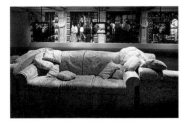 FEMINIST ANALYSES OF THE MESHING OF THE PERSONAL WITH THE POLITICAL, THE INFLUENCE OF PSYCHOANALYSIS ON THE INFLUENCE OF THE FAMILY, THEORIZING THE DENSITIES OF PERSONAL EXPERIENCE AND THE REVIVAL OF STORYTELLING: *PATTERNITY* (1991)

The engagement with the politics of the gaze, as exemplified by Jeff Wall, has been stood on its head by feminist artists such as Mary Kelly in *Interim* (1990), by Sorel Cohen

whose works combine spectatorship with domestic role playing, by Kati Campbell in *generic* (1988) and by Susan McEachern with her spectatorship of the de-peopled domestic environment. Their work returns some of the onus for epistemological enquiry to the viewer.

In what Sara Diamond calls "the theoretical living room" of *Patternity* we find the domestication of that discourse which has given women an intellectually defined space in which to debate the construction of their own identities. The tone, as Diamond observes, is ironic, "which doesn't get one too far these days when wars are fought with irony on television" but remains, nonetheless "the favourite recourse of the oppressed, somewhere between the didactic and hysterical."[10]

Soft furnishings are read as a specifically female contribution to the domestication of interior space. For all the crises in the nuclear family and its habitat, there remain cushions to be fluffed and curtains to straighten when guests are expected. Susan Schelle's *Taste* (1988) probes this social fact for further discomfort. The *Patternity* installation with curtains and couches domesticating the gallery, is completely imprinted with photographically derived "patterning." Photographic reproduction has revolutionized the way in which pattern (design) is applied to fabric, moving it ever further from the handmade and conjoining it with the plethora of media capable of bearing mass-produced imagery. Diamond uses it as an ironic metaphor for ways in which the pattern of our responses to life are laid down.

The decor both challenges and succumbs to the architectural givens of this windowless room. The curtains that Diamond has hung over the represented windows do not hide the view but bring it into the room. The protective draperies of the social space in which they are habitually represented are of no use. They bear scenes of the epic struggles between races, street scenes against which curtains can be a protection, a blind. Here the city is mapped onto the furniture, photographically, countering its rounded coziness with the abstract grid of the New York subway. Either the domestic interior has conquered, by countering, the patterns, the struggles, the terror, the alienation, of the city outside or, as seems more likely, the interior/exterior distinction was ever a delusion. Dominique Blain uses photography to dissolve this distinction, and to politicize it, through her appropriation of a quintessentially public emblem.

Diamond's *Patternity* is dominated by the "word of the father," to use Lacan's epigram for the *primum mobile* of human consciousness.[11] Her father's voice, gestures and stories about his own urban life, fill the spaces between the patterned furnishings, patterning the environment as he had patterned her life. The all-overness implied by this patterning works against any position. "There is no truth, only positioning and motivation," intones one of her texts.[12] In this ultimate relativism there are no privileged positions and no privileged authorities. The artist's intent is, constantly, to re-work the stories so that they are disrupted, transformed. The pattern is constructed with help from some of the voices that exemplify the course of postmodernist theory: Michel Foucault, Jacques Lacan, Michèle Montrelay and Trinh T. Minh-Ha, fragments of whose thought contribute pattern pieces rather than linear arguments. Text and photo-derived imagery have been conjoined in an environment that is at once claustrophobic and exposed.

For Diamond, the information which she must process is understood then as an explosion of ideologically mediated images, images which Shelagh Alexander internalizes with her compilation photographs. There is no possibility of straightforward material of the kind considered in *Wavelength.* The period between these two works has witnessed the fascination with theories of communication and information, the project of conceptual art to reach for some essential behind its dematerialized objects, and the understanding of images as readable texts with memory, all of which have variously impinged on the directions taken in subsequent photographic practice. This can only be crudely generalized as an investigation of the relationship between knowledge and perception, with the possibility that they are the same thing.

In the writings of Roland Barthes, photography acquired a philosopher of its own who used semiotics to explore the possibilities of a theory of the photographic sign. It was a theory which scrutinized equally the imagery of the mass media and commercial photography on the understanding that contemporary society is a universe of signs. The conventions of what is called fine-art photography were left behind. In part, as a result of the work of the French philosopher Jacques Derrida, photography came to be allied

with language to which all speakers had rights to make it speak in their own voices, and the photograph came to be associated with various contestatory cultural practices by feminists, gay activists and minority groups; that this is not simple protest art becomes clear when these voices are submitted to the kind of scrutiny that characterizes the photo-based work of Jamelie Hassan and Ken Lum. Cultural theory has found ways of breaking down some of the barriers between literary criticism, political theory, the social sciences and the visual arts. But it cannot be forgotten that photography has a long and complex history, increasingly re-visited. The engagement of the camera with politics has been understood to be of more than documentary nature for decades. The interface between photographic practice and intellectual currents has become immensely complicated, in ways that can only be abbreviated misleadingly. In modes that have been lyrical, hermetic or dramatic, making use of pastiche and irony, there has been fundamental query, challenge, deconstruction, and now, in certain quarters, the interrogative is being replaced with assertion. This is an assertion of the rhetorical power of photography which emphasizes that the representations achieved by the camera are, like all others, social facts.

By invoking these works as exemplars I have tried to show how they and, by implication, many others have marked a process of epistemological enquiry in visual terms, and a process for working through the complex relationship between theory and practice. However, it would be wrong to suggest that there is some shared, Canada-wide photo-discourse in which all these artists are engaged. In fact, in art as in other matters, different parts of the country have different histories and are variously affected by different currents of thought from beyond its boundaries and from within. During this period, the discourses have become more diverse, some would say arbitrary, but it is not risking much to observe that photography is inextricably linked to the most necessary epistemologies of the times.

NOTES

1 The term DECIDEURS is used by Henri Cueco and Pierre Gaudibert throughout their examination of the power politics of the international art world, L'ARÊNE DE L'ART (Paris: Éditions Galilée, 1988).

2 The work of the French anthropologist, Claude Levi-Strauss, was widely read at this time and was largely responsible for making the tenets of structuralism, themselves based on structural linguistics, accessible to a wide audience. Levi-Strauss had published THE ELEMENTARY STRUCTURES OF KINSHIP in 1949 but was best known to this audience for STRUCTURAL ANTHROPOLOGY first published in English in 1963 (it had appeared in French in 1958).

3 Jeff Wall's reading of monochrome, which expands on an idea of Benjamin Buchloh's, is set out in his "La Mélancholie de la rue: Idyll and Monochrome in the Work of Ian Wallace 1967-82" in IAN WALLACE: SELECTED WORKS 1970–1987 (Vancouver: Vancouver Art Gallery, 1988), 63.

4 See, for example, Marshall McLuhan and E. S. Carpenter, EXPLORATIONS IN COMMUNICATION (Boston: Beacon Press, 1960), and Marshall McLuhan, UNDERSTANDING MEDIA: THE EXTENSIONS OF MAN (New York: McGraw-Hill, 1964).

5 I am thinking here of Norman Bryson's account of perceptualism as set out in VISION AND PAINTING: THE LOGIC OF THE GAZE (New Haven and London: Yale University Press, 1983).

6 An examination of the role of the N.E. Thing Company is overdue. Extensive research into its history is being undertaken by William Wood, a part of which appears as "Capital and Subsidiary: The N.E. Thing Company and Conceptual Art" in PARACHUTE 67 (July, August, September 1992), 12–16. Wood, with Nancy Shaw, is to be the curator of the exhibition, YOU ARE NOW IN THE MIDDLE OF AN N.E. THING COMPANY LANDSCAPE, for the Fine Arts Gallery at the University of British Columbia in 1993.

7 For an analysis of these works which attempt to distance them from the miasma of simulacrum studies and to preserve the possibility of "an oppositional culture," to the construction of which they contribute, see Dot Tuer, "Columbus Re-Sighted," in THIRTEEN ESSAYS ON PHOTOGRAPHY (Ottawa: Canadian Museum of Contemporary Photography, 1990).

8 Robert Linsley, "Image Literatures," CAMERES INDISCRÈTES (Santa Monica, Barcelona: Centre d'art Santa Monica, 1992), 115.

9 Stan Denniston, REMINDERS (Victoria: Art Gallery of Greater Victoria, 1978).

10 From the artist's notes for her talk on the panel held at the Vancouver Art Gallery in connection with the exhibition of PATTERNITY on January 28, 1991.

11 "The word of the father" is a phrase much used by French psychoanalyst and social theorist Jacques Lacan. It summarizes one of his ideas which has greatly influenced feminist debate — that western society's logocentrism is intimately associated with its phallocentrism. See, for example, Jacques Lacan, ÉCRITS: A SELECTION (London: Tavistock, 1977).

12 Wallace, "Photography and the Monochrome," 121.

PHOTO CREDITS

Page 11: Michael Snow, WAVELENGTH, 1966-67. 16 mm film , 45 minutes. Collection: National Gallery of Canada. Courtesy: National Gallery of Canada. Page 13: Iain Baxter, PORTFOLIO OF PILES, 1968. Photo offset lithographs, 16.5 cm x24 cm, edition of 555. Courtesy: Alvin Balkind. Photo: Iain Baxter. Page 15: Melvin Charney, FRAGMENTS...LA MAISON DE RIVIÈRES-DES PRAIRIES, 1977. Gelatin silver print, 25.5 cm x 20.5 cm. Collection: the artist. Courtesy: the artist. Photo: Roger Thibault. Page 16: Jeff Wall, PICTURE FOR WOMEN, 1979. Cibachrome transparency, fluorescent light, display case, 163 cm x 229 cm. Collection Musée Nationale d'Art Moderne, Centre Georges Pompidou, Paris, France. Courtesy: the artist. Photo: Jeff Wall. Page 17: Stan Denniston, REMINDER #3 (LEFT: VULTURE MOUNTAIN RD., NEAR WICKENBURY, ARIZONA. RIGHT: HWY. 4 AT MACMILLAN PARK, NEAR PORT ALBERNI, B.C.), 1979. Gelatin silver prints, 27.8 cm x 35.4 cm (each sheet). Collection: Art Gallery of Ontario. Courtesy: the artist. Photo: Stan Denniston. Page 18: Wilma Needham, SOME FINE WOMEN - PORTIA WHITE, 1983. 35 mm slide, projected 1.83 m x 6.1 m. Collection: the artist. Courtesy: the artist. Photo: Wilma Needham. Page 20: Liz Magor, FRANZ BOAS AND OTHERS, 1991. Inset photographs, 152.4 cm x 53.3 cm. Collection: the artist. Courtesy: the artist. Photo: Liz Magor. Page 21: Sara Diamond, PATTERNITY, 1991. Video Installation: 3 videotapes (130 minutes each) simulcast on 8 monitors with screenprint and photo transfer on fabric. Collection: National Gallery of Canada. Courtesy: Vancouver Art Gallery. Photo: Trevor Mills

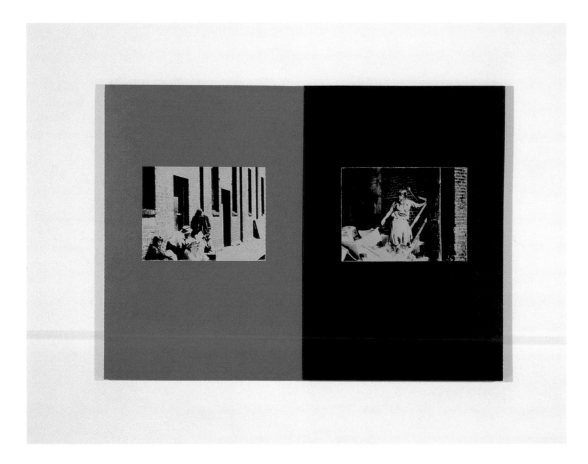

POVERTY, 1982. Silkscreen and acrylic on canvas, 1.82 m x 1.22 m each. Collection: The Banff Centre. Courtesy: Walter Phillips

Gallery, Banff, Alberta. Photo: Monte Greenshields

Ian Wallace's POVERTY

Scott Watson

In 1982, Ian Wallace made twenty canvas panels, called *Poverty,* which were the culmination of a number of projects all involving the same images.[1] The series of images was first produced as a 16-mm film in 1980. Using friends as actors/models, Wallace staged a series of vignettes on the theme of the urban homeless. Reference to Italian neo-realist cinema and late nineteenth-century photographers of the urban poor such as Charles Negre, Wallace's images had a "period" Depression era look to them. The types are somewhat heroic and border on the sentimental, the hobo and the gamin, the kinds of characters one finds in the films of Charlie Chaplin. The situations are both urban and pastoral. A nineteenth-century warehouse façade, a heap of refuse in an alley and a park are the three settings for the male and female characters. The characters are shown walking, reading, conversing, relaxing and, in one scene, engaged in erotic play. In some of the images the models seem posed, in others as though caught unaware. There is much potential for a narrative and allegorical reading of the images. As is often the case in Wallace's work, especially the large photo-murals of the seventies, the allegory is about art and the utopian longings which animate the modernist aesthetic project.

The slightly discordant note struck by the images is created by their unexpected stress on relaxation which is out of character for "artistic" or documentary representations of the urban poor. We do not usually see this "type" of person reading, for example, so the work suggests that these dispossessed are artists and intellectuals who, like the bums in the picture, operate at the margins within highly circumscribed roles. The

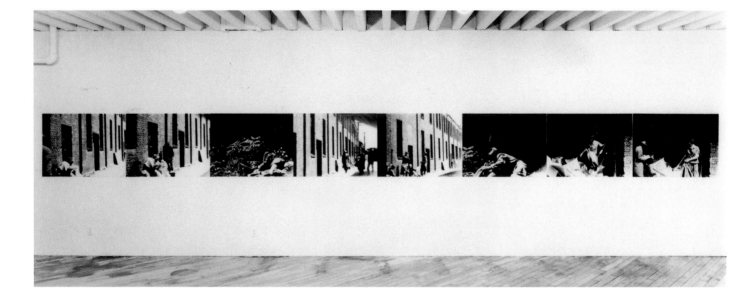

P O V E R T Y, 1980. Black and white photgraphs, 91 cm x 9.8 m. Collection: Canadian Museum of Contemporary Photography,

Ottawa, Ontario. Courtesy: the artist. Photo: Ian Wallace

pastoral aspect of the images might indicate a kind of utopian, even redeemed, state of being. As Theodor Adorno put it, "None of the abstract concepts come closer to fulfilled utopia than that of eternal peace."[2]

From the individual frames of the 16-mm film Wallace made eight lithographic studies and also a large black and white photo-mural later that year. Traces of cinematic sequence remain in the selection of the images which are paired to indicate the passage of time. He also made a tape separating shots from the film with "blank" passages of monochromatic colour. In 1981, he produced a small xerox book using eight images from the film, giving each black and white image a monochrome tint. Finally, after experimenting with various techniques he silkscreened the images on canvases where they were surrounded by monochrome fields. The *Poverty* series resulted from this technique.

This marked a return to painting for Wallace. He had painted monochromes in the late sixties but had produced photographic work in the following decade. As his subsequent work continued to develop the strategies of *Poverty* – juxtaposing a monochrome element with a photographed image – the series marked a turning point for the artist. Preceded by a decade of large photo-murals with a strong cinematic reference and narrative component, *Poverty* clarified what Wallace regarded as two poles of his avant-garde position and practice.

In a catalogue essay for Wallace's 1988 *Selected Works: 1970-1987* exhibition at the Vancouver Art Gallery, Jeff Wall reported that the stimulus for the *Poverty* paintings came from a reconsideration of Andy Warhol's two-panel disaster paintings (1963), which Wallace had seen at the *Westkunst* exhibition in Cologne in 1981: "In these works [Warhol's], both panels are painted the same colour, but only one has been silkscreened with Warhol's characteristically repeated images. The other is blank. A more precise formulation of the polarity between polemical imagery and the ambiguity of the monochrome could hardly be imagined."[3] It is Wall's contention that the "contradictory solidarity" between these two forms of radical art is a "central problem in the conceptualization of vanguardist culture."[4] In *Poverty*, as in Warhol's two-panel works, this solidarity and its contradictions are brought to the fore. For Wall, the monochrome

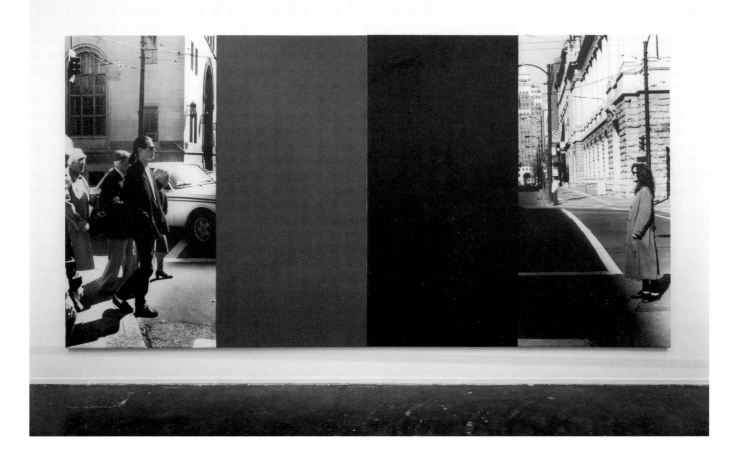

AT THE CROSSWALK, 1986 — 88. Photolaminate and acrylic on canvas, 2.44 m x 2.34 m. Collection: National Gallery of

Canada, Ottawa, Ontario. Courtesy: the artist. Photo: Stan Douglas

element in the *Poverty* paintings signalled "a restoration of transcendental and formalist aesthetics."[5] Wall argues that Wallace is a Symbolist of sorts and that in his work since the mid-seventies there has been a "drift toward a monumental art of high interiority rooted in the reprise of Symbolist idealism centred in the aesthetics of Mallarmé."[6] *Poverty* would appear to be directed to an aesthetics of withdrawal rather than engagement while at the same time deploying images and subjects that we expect to be treated in a politicized and polemical fashion. That the "subject," poverty, is not dealt with in such a way has led to charges of artistic irresponsibility.[7] These are based on the denial of literalist expectations. As Wall put it, by avoiding polemical images which might recriminate or offer a critique of social reality, *Poverty* is "in a state of tension with the liberal progressive consensus of the art world."[8]

The pessimism of the series is only aggravated by the effortless, indifferent and unexpressive choice of colours for the monochrome element. The bright colours and their flat application do not restore painting as an affirmative, autonomous cultural object; instead, they ruin that possibility in our present moment. Yet their idyllic images are presented using utopian grammar.

The transition marked by *Poverty* represents the intersection of a decade of large, cinematic and allegorical photo-murals and a decade of painting. The paintings produced after *Poverty* refined the use of a photographed image and a monochrome element, a strategy that seemed flexible enough to enact Wallace's multiple concerns as an artist. In the eighties Wallace defined three thematic concerns and produced a paradigmatic series on each: the studio, the museum and the street. These are the public and private spaces for art and artists that define the relationship of art and society. In this context, *Poverty* offers the images of the street as objects made for the museum and involves a dialectic between these two spaces. The rupture between them is alienating; they are both reified spaces. The modern street and the modern museum are both emblematic of the public space which ought to be, but is not, the site of revolutionary potential. The dialectic between these spaces is inoperative in contemporary society because there is no interaction between them. The potential for this dialectic exists in the *Poverty* paintings although they also "illustrate" the ruination

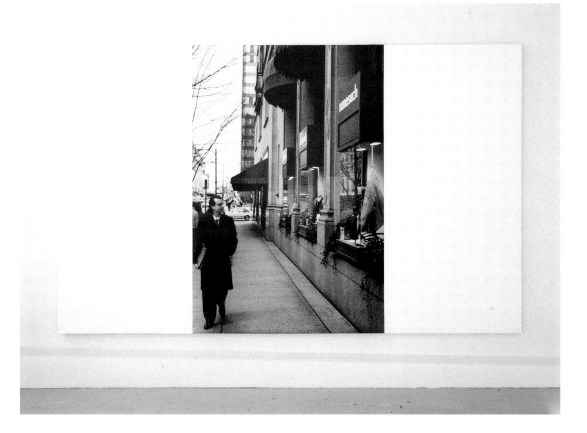

MY HEROES IN THE STREET (DOUG), 1986 — 89. Photolaminate and acrylic on linen, 1.82 m x 3.05 m.

Collection: the artist. Courtesy: the artist. Photo: Paul Arboz

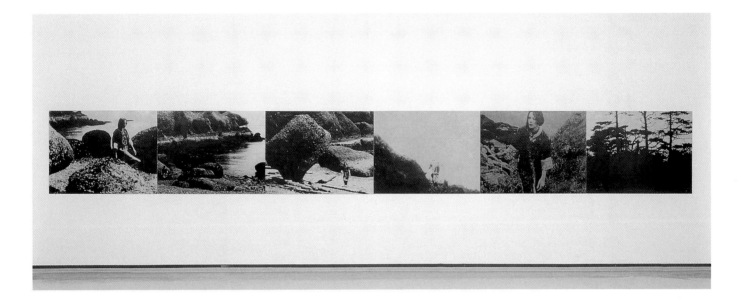

COLOURS OF THE AFTERNOON, 1977. Hand-coloured black and white photographs, 91 cm x 7.31 m. Collection: FRAC,

Corsica, France. Courtesy: the artist. Photo: Winnipeg Art Gallery

and futility of the street/museum dialectic upon which they themselves comment.

Poverty does not speak directly to the viewer nor does it attempt to do so. Rather the paintings are literary and allegorical and demand a certain amount of theoretical sophistication on the part of the viewer. They do not represent self-sufficiency as objects; therefore, the modernist faith in the autonomous aesthetic object is questioned. At the same time, however, they refer not to the restoration of this faith but to the possibility of holding the contemporary contradiction in full view, without premature and hence false resolution.

It is perhaps too early to attempt to locate Wallace's work within its historical context. We still inhabit this context and it is doubtful that we could know what the present will produce for the future. But there is enough criticism and analysis of the late capitalist era to presume that *Poverty* both reflects upon and is produced by its historical moment. The abstractions of capital and property, the ghosts of class struggle and bourgeois melancholy, all leave their marks on the material production, the imagery and the language of *Poverty*. The urban images of *Poverty* appear timeless, frozen in the past, in contrast to actuality in which the urban environment is extremely unstable, dynamic and subject to the dehumanizing forces of large corporate development, often under the guise of the renewed "humanism" of postmodernism. This distance between actuality and its representation may be the cause of the difficult reception of *Poverty,* the "tension" it creates in the viewer and the irritant it offers to the world. In this sense *Poverty* is a political work, not at all comforting, but an incitement to awareness and heightened consciousness of the modern dilemma.

Consumption for the home is kept distinct from the economy as a whole.

NOTES

1 The work in the collection of the Walter Phillips Gallery is a diptych made from two of these panels.

2 Theodor Adorno, MINIMA MORALIA: REFLECTIONS FROM DAMAGED LIFE, trans. E. F. N. Jephcott
 (London: NLB, 1974), 157.

3 Jeff Wall, "La Mélancholie de la rue: Idyll and Monochrome in the Work of Ian Wallace 1967-82," IAN WALLACE: SELECTED
 WORKS 1970-1987 (Vancouver: Vancouver Art Gallery, 1988), 70.

4 Wall, 63.

5 Wall, 74.

6 Wall, 68.

7 Richard Rhodes in a review of an exhibition of POVERTY held at the David Bellman Gallery in Toronto (VANGUARD 11:2
 [September 1982]) articulated the difficulty the Toronto art audience had with the series. "What a comfort this is, and what a
 lie," Rhodes wrote. His discomfort was based on his reading that the pictures were untrue to their subject and that "poverty
 as a social context...doesn't come through in the work."

8 Wall, 70.

DOMESTIC IMMERSION, PART II from the series **ON LIVING AT HOME**, 1988.

4 ektacolour prints, 41 cm x 51 cm each. Collection: The Banff Centre. Courtesy: Walter Phillips Gallery,

Banff, Alberta. Photo: Monte Greenshields

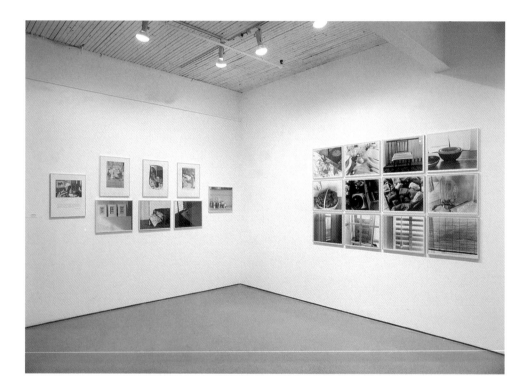

ON LIVING AT HOME (installation view), 1988. Ektacolour prints. Collection: the artist.

Courtesy: Mercer Union, Toronto, Ontario. Photo: Peter MacCallum

Domestic Subversion:
Susan McEachern's On Living at Home

Cheryl Simon

> To photograph is to appropriate the thing photographed. It means putting oneself into a certain relation to the world that feels like knowledge, and, therefore, like power....There is something predatory in the act of taking a picture. To photograph people is to violate them, by seeing them as they never see themselves, by having knowledge of them they can never have; it turns people into objects that can be symbolically possessed.[1]
>
> Susan Sontag

This may very well be *the* idea that sparked the debate on ethics and photographic representation so energetically sustained for the past ten years, a debate that has so radically affected the practices and criticism of documentary photography that it may never be the same again.[2] This is the debate over photographic objectivity and documentary "truth" that has sought to expose the documentary agenda as one of seizure, objectifying the lives and experiences of its subjects; "authorizing certain images while blocking, prohibiting or invalidating others."[3] This is the debate which aimed to reveal the extent to which the photograph, as it occurs within popular culture, is inextricably tied to the ideological agenda of a capitalist economy as a means of maintaining its status quo. So began the revolution in and reinvention of documentary

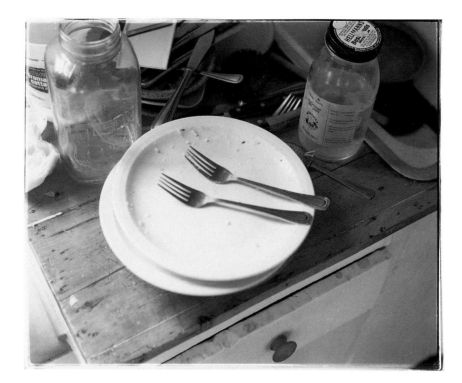

PHOTOGRAPHS OF THE PREPARATION OF FOOD (1 in a series of 35), 1981. Ektacolour print, 41 cm x 51 cm. Collection: the artist. Courtesy: the artist. Photo: Susan McEachern

photography as a practice working "against the grain" of the dominant cultural mode by subscribing to a concept of documentary "fact" that considers truth relative to the conditions by which it is both gleaned and presented. (Within a capitalist economy these conditions tend to be one and the same.) Documentary photography, in this reinvented conceptual model, is only relatively true.

It is ironic to look back at Sontag's quotation now and appreciate (perhaps even celebrate) the extent to which its meaning has altered with time. It is as much the contemporary photographic artist's intention to appropriate the things that she photographs as it is to put herself "into a certain relation to the world that feels like knowledge and therefore like power." No longer the exotic or foreign "other," the actual subject now is, more often than not, the photographer herself – portrayed as subject to the ideologies of the systems within which she lives. Now the act of photographing is intended to give power back to the subject by providing insight into the ways in which she has been already, otherwise, symbolically possessed by her representation in popular culture.

The subject of Susan McEachern's photographic work is always Susan McEachern, not bodily, but conceptually, as she is represented by the domestic sphere and her role within it. *Photographs of the Preparation of Food* (1981), *The Family in the Context of Childrearing* (1985), *On Living at Home* (1988) and recently *The Creation of Desire* (1990), all explore, as their titles might indicate, issues extracted from her private life and its social relations. More to the point, it is the articulation of the relations between private and public life that is McEachern's primary theme. In photographing the home as a place of both comfort and responsibility McEachern maintains the private sphere to be ideologically held in "a certain relation" to the public world. Her practice insists that knowledge of that relation is essential in order to effect change in either realm.

With *On Living at Home,* McEachern considers the ways in which the home is conceptualized as an extension of women's sense of self and how this self is aligned in the public/private relationship. Organized as a loose narrative of four interleaved parts, *On Living at Home* is grounded in the contention that "gender is basic to the 'economic' division of labour and how labour resources are controlled":[4] Part I, "Agoraphobia,"

Text within the image:
LONG AGO PEOPLE

used to dress their children in different colours so that people could tell who was who. Blue was a powerful colour and pink was a weak colour.

Later it was found that boys wore blue and girls wore pink. A time came when everyone wanted to be strong, so they all wore blue. Pink was forever removed from the world

and that is why there are no more sunsets.

STORIES WE TELL OURSELVES, PART II from the series **THE CREATION OF DESIRE**,

1991. Ektacolour print, 51 cm x 61 cm. Collection: the artist. Courtesy: the artist. Photo: Susan McEachern

considers the premises by which domestic isolation is maintained; Part II, "Domestic Immersion," addresses the politics of housework; Part III, "Media Consumption," treats the media as a fantasy resource for maintaining the status quo; and Part IV, "The World Outside," is an examination of the home in the context of world political economy. Locked out of the public realm and subordinated by a capitalist objective to maintain unpaid service labour, women's identity in western society, as McEachern observes, has been systematically and purposefully determined. Further, McEachern insists that "consumption for the home," while intrinsically tied to the marketplace, "is kept distinct from the economy as a whole"[5] through the more and less subtle persuasions of the mass mediated concepts of femininity. Women's magazines, in particular, have functioned as a "bridge between the home and the marketplace,"[6] using rhetoric directed at women that encourages complicity in their own subordination by "sanctifying women's domestic labour as a 'labour of love.'"[7] Such incentives, intimately connected to one's sense of self in relation to the world, provide a constant threat to women's identity as independent and self-determined. "The self-sacrifice involved in the responsibilities of caring for others causes disintegration of the self when the boundaries between you and those others can no longer be clearly defined."[8]

Adopting what Richard Bolton has called an "instrumental postmodern" agenda, McEachern's practice "aims for the removal of...systems that *oversimplify* experience and deform human potentiality,"[9] systems much like that of the women's magazine. Employing a metonymic documentary approach, McEachern utilizes "information that lies 'next to' the referent under discussion...[to point] to actual relationships that [traditionally] have been ignored, [and thus explodes the] traditional frameworks of analysis...[by] providing knowledge of the way that reality is defined by the exercise of power."[10] For McEachern this information is, to a large degree, found in the very forms and systems of representation itself. Her strategy is to complicate the representational power that the notions of singularity and "truth" in the magazine and news story, fairy tale, television program, romance novel or other representational vehicles exploit in the course of characterizing a normative female role through procedures of multiplication and intertextual analysis.

Comprised of a series of forty-one photographs in total, *On Living at Home* is a juxtaposition of "appropriated" illustrations of fairy-tale romance and happy family life along with a paradoxical "borrowing" of the women's magazine editorial format. In McEachern's version, the format consists of lush, colour coordinated, graphically striking, highly composed images of household products and the fruits of home labour inlaid with "editorial" citations from nineteenth- and twentieth-century feminists, social and cultural critical texts, statistics, reproductions of text excerpts from popular media and McEachern's own analyses. Less explosive than radically discordant, the effect is purposeful. But it is not so much a temperamental contrast in the singular groupings that invokes discord, rather it is the diversity of tone and accent of the multiple languages used in sum that diverge from the consonance found in its referent – the concept – as it is nurtured in the representations of popular culture, of the domestic sphere as an ideology-free zone. For example, the introductory image of *On Living at Home,* an outdated, (fifties) colour illustration of "the nuclear family" happily at play in a recreation room – a room, not inconsequentially devoid of signs of domestic labour – is not discounted but analyzed by the Rosalind Coward quote that accompanies it:

> The ideology of the domestic sphere and the love of a good woman allowed people to treat their homes as if the economic world did not exist and as if individuals were not implicated into the injustices of the world.[11]

Rather, it is the thematic that follows, the similar and dissimilar representations of domestic "harmony" that McEachern has set in relative isolation from the world, that deconstructs the image and expands on the analysis of the text in an effort to destabilize this primary referent. In Part II, McEachern uses the challenge of nineteenth-century feminist Catherine Beecher:

> Let any man of sense and discernment become the member of a large household, in which a well-educated and pious woman is endeavouring systematically to discharge her uniform duties...it is probable that he would conclude that no statesman...had more frequent calls for wisdom, tact...and versatility of talent than such woman.[12]

However, combined with a pristine china and linen place setting, McEachern's usage forgives Beecher's anachronistic feminism to challenge in kind the sense of naturalized domestic leisure that the image is used to illustrate – the type of class and gender consciousness that typically is exploited to reinforce this idea.

Addressing the ways in which domestic and social experience – real and/or represented – can deviate radically from the particularly potent romantic "norm" promoted in advertising, McEachern picks up the thematic thread of love and femininity in Part III, introduced by the phrase "the love of a good woman." She changes the point of view by juxtaposing highly stylized representations of fairy-tale types of romance alongside "documentary" photographs of the instances of mass mediation in her own home and appropriated images of social and sexual violence against women and minorities taken from television news and drama.

Less explicit, but nonetheless persistent, this violence/pleasure dichotomy continues in McEachern's summary, reinforcing the obvious and persistent relationship between the private and public spheres. In Part IV, otherwise benign scenes of home life – Granny Smith apples in bowls on kitchen counter tops, coffee perking and canoes at rest in landscaped backyards – become much less so in light of McEachern's statistical analysis of the economic and physical costs of such leisured comfort and privilege on the world outside the domestic realm. McEachern's relentless layering of these differing representations is intended to hold their otherwise deferential interpretations in check.

Her objective here is less to "reveal, expose, 'unveil'...[the] hidden ideological agendas in mass-cultural imagery,"[13] than to set them up to reveal themselves by disrupting the linearity of the logic with which those representations empower themselves. This is the same logic that presumes that to unveil would be to lay bare, that there is the possibility of an ideologically free representation, that there is a possibility – no, a probability – that one can exist outside of representation. For McEachern reality is neither ideologically pure nor purely ideological but concomitantly both. That the information lying next to the referent in McEachern's work is in conflict follows logically and forcefully from her premise. The referent here is the arena of conflict "between public/private, external/internal, the collectivity/the individual and

THE FAMILY IN THE CONTEXT OF CHILDBEARING (1 in a series of 165), 1985.

Ektacolour print, 41 cm x 51 cm. Collection: the artist. Courtesy: the artist. Photo: Susan McEachern

vulnerability/safety,"[14] or even representability/non-representability. It is the space between the prescribed dichotomy of social and private life. It is the space of the female self, a space where dichotomy necessarily exists, its oppositions laid beside each other – not integrated or homogenized, but in conflict. And so it is self-consciously then that when *On Living at Home* images the private, literally internal and individual aspects of the female self as represented in relation to the home – "the object of countless 'narcissistic' choices that endow it with the potential to be experienced as an extension of the self or self-object, one that calms and reassures,"[15] – to allude to a place seemingly outside of representation, it does so with the conflicts in its own representational function intact. While each object clearly has sentimental value for McEachern personally, each subject is classically photogenic. Each image glimmers with vibrant association, all representative of very particular and very publicly acknowledged kinds of classed and gendered desire. The text of *On Living at Home* is likewise ambivalent. While designed to presume a place of representation, a public, externalized voice of collective consciousness traditionally conceived of as outside of the self, the predominant voice in quotation here is still McEachern's own. It is a voice informed by a collective consciousness, certainly, but one, nonetheless produced through a private conflict between socialized aspirations and another kind of desire – perhaps politicized, perhaps instinctive and self-preserving, but a strong and directive kind of impulse all the same – to reject what the imagery proffers as ideal.

McEachern's imagery and text, like the private and public realms, the real and its representations or even documentary fact and dramatic fiction, co-exist. Their oppositions are manifold. They prevail "concurrently and in contradiction. The movement between them is not that...of difference but is the tension of contradiction, multiplicity and heteronomy."[16] This is not to say that these relationships are fixed. On the contrary, they are only tentatively and temporarily grounded, held relative to the conditions or relations by which they are represented and gleaned. This is the point of McEachern's campaign. As these relationships are only fixed so long as they go unnoted, so long as they maintain an image of integrated, combinatory, reciprocal restraint, *On Living at Home* notes them. This is a naming project, it names the ways in which we are

held in relation to the world, the ways in which the representations of popular culture, with their linear logic and culminative truth, perpetrate our fear of conflicting desires and in doing so engineer the maintenance of a rigid status quo. Envisioning a female self in potential, in a multiplicity of relations with the world that are constantly changing but in particular in "a certain relation to the world that feels like one of knowledge" as Sontag describes, McEachern's project champions conflict and with it the belief that it is only through feeling and knowing the conflictual nature of our relationships in the world that we are inspired to exact agency and bring about change.

NOTES

1 Susan Sontag, "In Plato's Cave," ON PHOTOGRAPHY (New York: Farrar, Straus and Giroux, 1977), 4, 14.

2 While Sontag was perhaps not the first critic to address these issues and is certainly not isolated in her opinion — see for example Alan Sekula's essay, "Dismantling Modernism, Reinventing Documentary (Notes on the Politics of Representation)" first published in the MASSACHUSETTS REVIEW 19:4 (Winter 1978) and Martha Rosler's "in, around and afterthoughts on documentary photography," 3 WORKS (Halifax: Nova Scotia College of Art and Design, 1981) — the mass publication of Sontag's collected essays did much to popularize the debate. The quote of Sontag's may be the one most popularly cited.

3 Craig Owens, "The Discourse of Others: Feminists and Postmodernism," THE ANTI-AESTHETIC: ESSAYS ON POSTMODERN CULTURE, ed. Hal Foster (Washington: Bay Press, 1983), 59.

4 Dorothy Smith, "Women, Class and Family," WOMEN, CLASS FAMILY AND THE STATE, ed. Dorothy Smith and Varda Burstyn (Toronto: Garamond, 1983), 2.

5 Susan McEachern, from ON LIVING AT HOME, PART II, "DOMESTIC IMMERSION."

6 Sally Stein, "The Graphic Ordering of Desire: Modernization of a Middle-Class Women's Magazine 1919-1939," THE CONTEST OF MEANING, CRITICAL HISTORIES OF PHOTOGRAPHY, ed. Richard Bolton (Cambridge: MIT, 1989), 146—47.

7 Ibid., 147.

8 McEachern, from ON LIVING AT HOME, PART II, "DOMESTIC IMMERSION."

9 Richard Bolton, "The Modern Spectator and the Postmodern Participant," PHOTO COMMUNIQUE (Summer 1986), 43 [my emphasis].

10 Ibid.

11 McEachern, ON LIVING AT HOME, PART II.

12 Ibid.

13 Owens, 72.

14 McEachern, MAKING SPACE (Vancouver: Presentation House, 1988), 14.

15 McEachern, ON LIVING AT HOME, PART II.

16 Teresa de Lauretis, "The Technology of Gender," TECHNOLOGIES OF GENDER (Bloomington: Indiana University Press, 1987), 26.

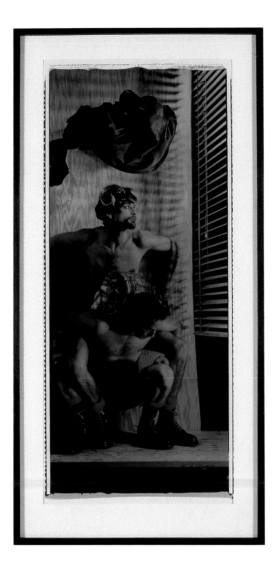

NIGHT WATCH, 1990. Colour Polaroid print 1/3, 2.24 m x 1.12 m.

Collection: The Banff Centre. Courtesy: Walter Phillips Gallery, Banff,

Alberta. Photo: Monte Greenshields

The Making of a Memory: Evergon

Alain Laframboise

Let Caravaggio's *Saint-Jean-Baptiste* stand as an epigraph.[1] A number of factors may account for the dissonant character this painting possessed when it first appeared, according to S. J. Freedberg. Among these are its verisimilitude, a realist quality in opposition to the guileful or classicizing character of mannerist imagery of the beginning of the Seicento,[2] and an apparently direct transcription from the model, one uninterested in the idealizing formulas of aesthetics normally associated with an intellectual conception of form such as might be found in Bronzino or Annibale Carracci. Rather, Caravaggio apparently chose models that departed significantly from the conventional criteria of beauty, presenting them in such a way as to produce a physical and psychological immediacy[3] that was, as much as possible, akin to the sensual perception of physical entities, with the attendant emotional charge of the subject, characteristic of his epoch. The aggressive presence here of a nude adolescent, in an exhibitionist and voyeuristic context capable of compromising the viewer, is, despite the iconographic alibis, a vehicle for the true subject of the painting, for its homosexual content. The "direct" quality of the transcription, the suggestion of optical and tactile apprehension, are unprecedented in painting of the 1600s. But it would be too much to say that Caravaggio wipes away an entire tradition with a sweep of the hand; one need only acknowledge the extent to which his figure's pose is indebted to Michelangelo's *ignudi* in the Sistine Chapel.[4] Consider the initial impressions created by Evergon's *Night Watch,* a large-scale Polaroid made in 1990. First, the explicitly sexual character of the

scene, its obvious reference to gay imagery, is evident in the two naked "wrestling" male models, their footwear, the ambiguity of their relationship. Then, reinforcing the sexual charge of the image, there is the "photographer's studio" look of the environment complementing the studied poses of the figures, the blind ostentatiously playing the role of accessory along with the set of drab, unpainted plywood. There are also unmistakable allusions to grand-manner painting – the curtain hovering in the upper area of the image, the "artistic" chiaroscuro[5] and, evoking the triumphs of the Renaissance, a composition showing a figure dominating (overcoming) another.[6] As for iconography, one would do well to keep in mind the ram's horns of the standing figure and the "headdress" of the crouched one, the latter consisting in a full-face mask representing a ram or goat. These identify the *Ramboys*,[7] liken them to the figures of classical mythology. Pan – bearded, horned and goat-footed – prowls nearby. A divinity with an insatiable sexual appetite who pursues nymphs and adolescents, Pan (whose name means the all) is a symbol of the sexual energy present in the universe. He is the god who excites the senses and agitates the mind and is associated with both unbridled sexuality and the social order. The symbolic figures of Pan, the ram and the goat can be read in a variety of ways, the nuances of which would vary considerably depending on the specific context. Thus, in the world of sorcery, the goat is the very image of lust and a satanic figure. In the work of Goya, it symbolizes abomination and the presence of the devil; his depiction of Satan shows him with the head of a goat. In Evergon's image, the Ramboy's horns now derive from the Venetian masks still made by today's artisans while the goat feet have been replaced by black paramilitary boots, quasi obligatory attributes of image registers found in certain "specialized" magazines.

Night Watch seems to function through a sort of oscillation, entirely strategic in nature, between the great models of art production and the variable formulas of soft- or hard-core pornography. It remains to be seen whether the *Night Watch* in question is that of the figure looking out upon a hypothetical night beyond the blind or whether it is intended to draw the viewer's attention to this problematic "nocturne." Conjuring up associations with Rembrandt's famous painting, the title orchestrates a considerable

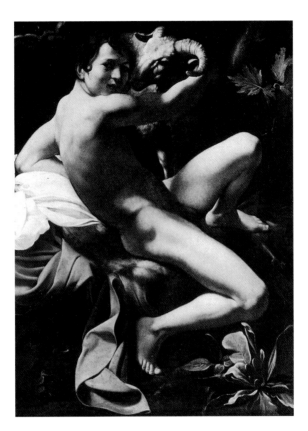

Caravaggio, **SAINT-JEAN-BAPTISTE**, 1597 — 98. Oil,

132 cm x 95 cm. Courtesy: Galleria Doria Pamphili, Rome, Italy

shift or at least suggests the existence of an analogy to be discovered between the two paintings, if only for the purposes of an ironic comparison focusing on the divergences between their objectives and fields of reference – for example, the hiatus between pictorial and photographic (indexical) devices.

It should be noted that all of the components of the image are presented in an extremely legible manner that ultimately arouses the desire to see still more. Everything – from objects to learned allusions, composition to processes – lends itself to naming. Thus the plates pulled away from the bottom of the frame to further demarcate the scene allow for a margin of shadow that enables the black in the image to coincide with the untouched matter of the Polaroid film itself, that is, where it has not been altered by exposure to light. The demarcation of the image, its definition, is rendered even more explicit by echoes from the irregular margins resulting from the Polaroid process itself. Naturalism, as well as the theatrical, pictorial and indexical, are all at work here.

Ramba Mamma, a large black and white photograph in the *Ramboys* series, is also loaded with allusions. The naked elderly woman wearing a thin veil and a mask that transforms her head into that of a goat immediately suggests a world of sorcery.[8] The connection between the meaning and place of this maternal symbol in the *Ramboys* series is instantly established, along with the attendant ambivalence. What is troubling is the semantic ambiguity of this figure, indeed of the whole image, composed as it is like a portrait made from a theatrically lit model disclosing all manner of unique detail – age, posture, skin texture, stoutness, disguising artifices – things, in short, that photography renders so well. The full power of this image derives from the ambivalence existing between the portrait and the mythological subject, the masked face and the archetype, the person and the divinity, the banal and the magical, the beneficent or malicious, the game or witches' sabbath, the maternal or satanic figure.[9] Observe that the whiteness of the mask, the serenity of the pose and the softness of the lighting considerably reverse the figure's baleful character, turn it into a less troubling "divinity" belonging to what one could call, following the nomenclature of magic, a world of white sorcery.

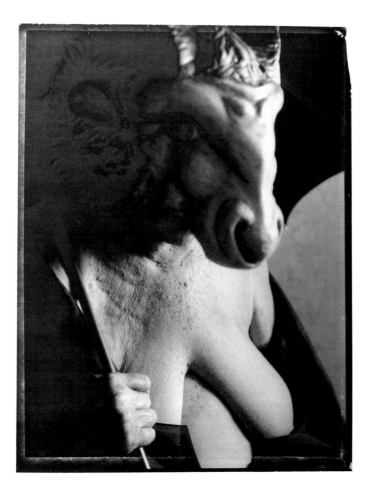

RAMBA MAMMA, 1990. Fibre-based black and white selenium toned photograph, 1 m x 1.52 m. Collection: M. Fulton. Courtesy: Jack Shainman Gallery, New York, New York. Photo: Evergon

THE CAPTIVE, 1990. Fibre-based black and white selenium toned photograph with silver leaf, 1.22 m x 1.52 m.

Collection: Bailey and Company, Inc. Courtesy: Genereux-Grunwald Gallery, Toronto, Ontario. Photo: Evergon

In a related work, *The Captive,* the chromatic saturation of *Night Watch* is replaced by a combination of black and white with silver. Covered partially in silver leaf, the photograph is designed to darken along with the clouding of the metal. There is a clash between the figure and the way it is treated. Emaciated, constrained, subjected to an implacable light, this figure thrown upon a stark piece of plywood floats as on a raft upon the surface of a metallic lake that will change with time, miming the photograph process in reverse, in a kind of inverted revelation. A living, mutable image, *The Captive* combines theatrical sadism with a delicacy of treatment and exhibits an almost documentary meticulousness in matters of detail along with the precious unreality of the icon, violence, brutality (staged) and an economy of means.

A current project, *Ramboys* is an ambitious project, one that Evergon foresees working on for the next five years. His "novel," as he calls it, will involve a considerable intermixing of references and endless interconnections, which he intends to supply by dipping into the reservoir of art history and classical mythology and by drawing upon literature and contemporary gay culture. Evergon seems to be trying to invent a mythology, one that would be none other than his own artistic fiction, a photographic narrative that would in some measure stand in for the founding myth of a "Boy Culture" still in the process of being constituted. The faun-like figures that appear throughout his work point simultaneously to a personal history (which they articulate)[10] and a collective one built upon a repertory of references accessible to a broad readership. Only by redirecting classical mythology and resorting to what Roland Barthes calls our modern mythologies[11] will the invention of this mythology be possible; it will also involve the appropriation of a good number of elements from the same classic heritage and their correlation with gay culture. If Evergon has played extensively upon allusions to grand-manner painting and the history of photography, he also seems to have opted for other more explicit registers that now mix so-called high art photography with low art, calendar art, and with what he himself would call "Ramboy photography." This undertaking necessarily entails openness to values and levels of reality that, in turn, call upon a multiplicity of media, devices and apparatuses. It would

also make it necessary to rethink a whole hierarchy of artistic values, one that provides the basis for the contiguities, the juxtapositions, the stylistic and thematic allotopias, as well as the broken registers and semantic contamination, that shape the new dimension of Evergon's work.[12] For the artist's real interest lies in a process of reception in which each new object and the information it contains is as important as the creation of individual, finished pieces.

NOTES

1 Two versions of this painting exist, both in Rome. One is at the Musei Capitolini, while the other is in the Galleria Doria Pamphili.

2 S. J. Freedberg, CIRCA 1600: A REVOLUTION OF STYLE IN ITALIAN PAINTING (Cambridge, Massachusetts and London: The Belknap Press of Harvard University, 1983).

3 Unmediated, that is, in keeping with established criteria of ideal beauty.

4 Freedberg adds: "A deliberate translation into realist prose of overt classical sources on the sacred SISTINE CEILING, the BAPTIST is not just an anti-ideal; it is a derisive irony, and in a sense a blasphemy, which intends an effect of sacrilege and shock — to which its contemporary audience would have been more susceptible than we," 59.

5 This could, of course, be read as studio lighting. Several elements in the image would thus provoke various associations.

6 One could even go as far as to see, in the interweaving of figures, an irreverent allusion to da Vinci's famous SAINT ANNE, VIRGIN AND CHILD, or to the Burlington House cartoon. Michelangelo subsequently made two drawings in which he attempted to resolve the compositional problems involved in "installing" the Virgin on Saint Anne's knees, a move that would break with a medieval compositional scheme judged to be too hieratic.

7 RAMBOYS is the title of a series, the first work of which, according to the artist, is NIGHT WATCH.

8 In 1986 Evergon completed an immense Polaroid triptych titled RE-ENACTMENT OF GOYA'S "FLIGHT OF THE WITCHES."

9 RAMBA MAMMA would thus belong among the cohorts of the Great Mother Goddesses. As with all symbols of this nature, it would have a double meaning associated with vital forces, with both life and death, and could alternately be life-giving, protective, castrating and dominating.

10 Understood as a phantasm.

11 That of Rambo included. One could elaborate an iconography for this paradigm of chauvinist and radical (to the point of being suspect) heterosexual virility, just as Barthes did for the Abbé Pierre.

12 Structurally speaking, these exhibit, beyond the possible thematic analogies, a homology with the procedures of W. S. Burroughs.

TRANSLATED FROM FRENCH BY DON MCGRATH.

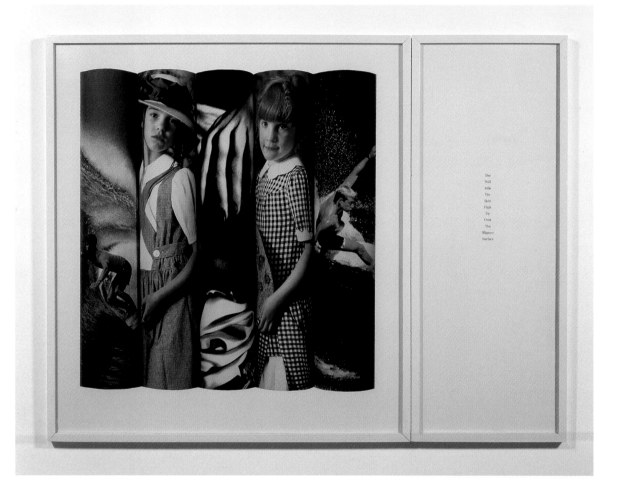

SHE WILL RIDE HER SKIRT... from the series **BURNING**, 1987. Colour photograph and colour-coded text, 1.4 m x 1.78 m. Collection: The Banff Centre. Courtesy: Walter Phillips Gallery, Banff, Alberta. Photo: Monte Greenshields

Questions of Complicity: Mark Lewis'
SHE WILL RIDE HER SKIRT...

Abigail Solomon-Godeau

Desire, the look, the field of vision, subject position, fetishism – these are some of the terms that have acquired currency and urgency within certain segments of contemporary art, critical theory and art discourse. As concepts for investigation by artists and critics alike, they emerged through the interplay of feminist and postmodernist theories of representation that began in the early 1970s. It was, of course, the foundational critical act of feminism to subject figurative representation – mass or high cultural – to critique and political analysis (as in the early work on images of women). However, within a relatively short period of time, psychoanalytic theory, poststructuralism and ideology critique had been variously conscripted to further elaborate, refine and indeed complicate the interrogation of imagery in its relation to the social, the psychic and the political.

The artists for whom this quintessentially critical project has been most central can in no way be said to constitute a school, a style or even a unified group. Employing disparate media, availing themselves of different methodological and theoretical schema, the product of varying formations, countries, ages and so forth, the artists cannot be easily categorized: one might as readily argue for the fundamental *difference* between, such artists as Victor Burgin and Mary Kelly as argue for their resemblance. Nevertheless, the centrality of the issues of spectatorship, subjectivity and desire to both artists and to so many of their contemporaries signals the importance and the influence of this particular discursive constellation.

The exploration of these elements, however, takes place against the larger cultural field of postmodernism and, however one wishes to define and distinguish postmodernism from its modernist antecedents, there is by now a more or less identifiable set of presumptions and tactics that permit for such a designation in the first place. Most conspicuously, postmodernism departs from modernism in its rejection of the notion of aesthetic autonomy; the domain of art is thus understood to be embedded and defined by its social, economic and institutional context. Hence, under the rubric of cultural presumption, one might note the general tendency to work within the terms of the already-read, already-seen, already-there, already-mediated, promoting the ubiquitous tendency to appropriate rather than fabricate imagery. Under the rubric of tactics, there is the equally prevalent embrace (critical or affirmative) of mass media and culture industry forms and images. Lastly, postmodernist art manifests a general historic shift from processes of unique, skilled, manual production (for example, easel painting) to processes of mechanical reproduction, a shift whereby artmaking itself assumes the form of industrial, commodity production. The logic of the commodity is, in fact, the structural armature of postmodernist culture across the board and, in this respect, the great divide within that culture concerns the position of the individual work with respect to this overarching frame. Thus, postmodern art may adopt a critical relation to the terms of commodity culture or a relatively untroubled embrace of it.

Mark Lewis' work is especially interesting in relation to this general context insofar as it not only encompasses these elements of postmodern art production but volatilizes them as well. A great deal of Lewis' recent photo-and-text work poses all the difficult questions raised by postmodernist theory but does so in ways that make it difficult to distinguish complicity from critique. In other words, by taking extreme risks with a highly charged set of mass-media signifiers – high-gloss imagery and texts that traffic with pornography and are themselves intensely fetishistic – Lewis abandons the high road of Brechtian distanciation to explore instead the more complex and ambiguous terrain of what Althusser called the interpellation of subjects.[1] Thus, where the goal of much contemporary critical art practice is to establish an ideological "outside," a critical space wherein, for example, the spectator is enabled to perceive the oppressions and/or blandishments of commodity culture, Lewis is more concerned with the mechanisms of

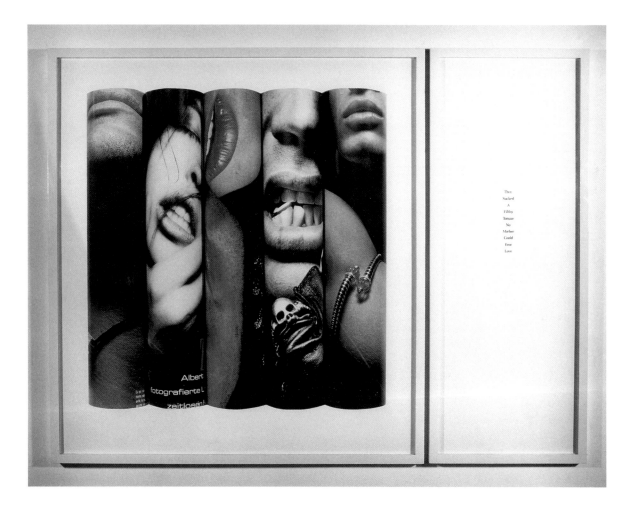

THEY SUCKED A FILTHY TONGUE... from the series **BURNING**, 1987. Colour photograph and colour-coded text,

1.4 m x 1.78 m. Collection: Student Society Gallery, University of British Columbia, Vancouver, British Columbia.

Courtesy: the artist. Photo: Mark Lewis

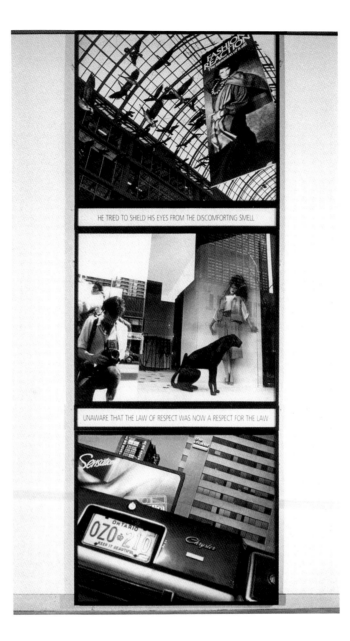

HE TRIED TO SHIELD... from the series ANOTHER LOVE STORY, 1985–86. 3 black and white photographs and

2 texts, 3.2 m x 1.14 m. Collection: Museum of Contemporary Canadian Photography, Ottawa, Ontario. Courtesy: the artist.

Photo: Mark Lewis

inscription, investment and entrapment. The operative term here is the subject's implication (from the Latin *implicare* – to be folded within) in the erotics of commodity and spectacle, an implication as much psychosexual as political, and all the more intractable for that.

She Will Ride Her Skirt... is a work that is especially provocative, evincing many of Lewis' most disturbing and discomfiting strategies. As with all the individual works in the *Burning* series, *She Will Ride Her Skirt...* follows a preordained format. Selected parts of photographic images from glossy magazines are isolated and exposed by rolling the page into columnar form, lining up the columns horizontally, rephotographing and enlarging them and then composing a colour-coded text that adjoins the ensemble as a discrete but integrally linked unit. Sometimes the columnar section will include the fragment of the advertising text that originally accompanied the image (in this case "She Will Ride Her Skirt High Up Over the Slippery Surface"); in other instances Lewis employs the image alone. In most cases the images can be recognized as derived from three provenances: advertising, fashion and pornography (soft and hard). The physical contiguity of the selected details, as well as the formal and thematic correspondences between them, establish at the outset the underpinning assumption; namely, that notwithstanding the difference between advertising, fashion and pornography, they share a common terrain, which is the subject of Lewis' analysis. Thus, the seductive slice of face or body, the glamorous icon of masculinity or femininity, an ecstatic mannequin or porno model, are literally re-presented as sites/sights on a continuum. In contrast to an approach to imagery that would distinguish between acceptable and unacceptable instances, between the erotic and the pornographic, Lewis insists on their genetic similitude, an analysis which itself was pioneered by feminist theorists.

In keeping with such a diagnostic, *She Will Ride Her Skirt...* is no less troubling than those works in *Burning* that avail themselves of the patently pornographic image. Thus, on the level of manifest content, the work confronts the viewer with, among other things, (appropriated) images of little girls whose pose and expression are fairly explicitly eroticized. However, the coy skirt-raising gesture of the little girl on the far right is arguably not more suggestive than the nymphet-like expression of the girl on the far left. The eroticism mapped on the little girls is further amplified by the central

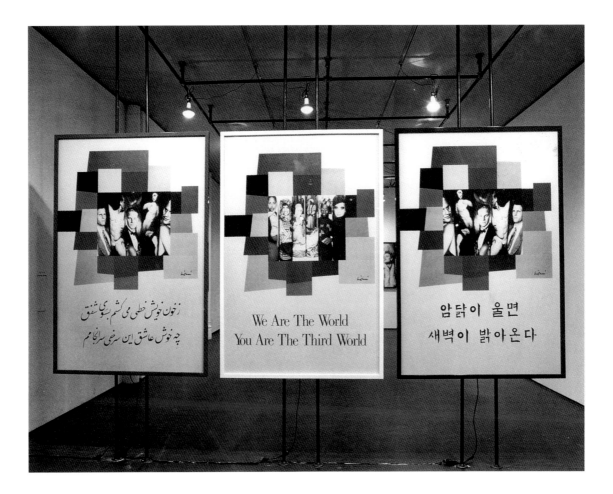

WE ARE THE WORLD / WHITE NOISE, 1988. 3 cibachromes, metal poles, smell machines, odour, 4 m x 3.7 m.

Collection: Museum of Contemporary Canadian Photography, Ottawa, Ontario. Courtesy: the artist. Photo: Mark Lewis

THINGS SEEN, 1990. C-print, 2 m x 1.52 m. Collection: the artist. Courtesy: WitzenHausen Meijerink,

Amsterdam, Netherlands. Photo: Mark Lewis

panel depicting a fragment of a woman's elegant hand with dark-polished nails, a section of black-stockinged thigh and crumpled folds of satin garment; the gesture implies the act of disrobing, unveiling, the promise of exposure. Bracketing the central imagery are two images of male surfers, bodies framed by the lustrous surface of water and, as one critic noted, the ejaculatory spume of foam.[2] The "framing" of the feminine by the male surfers and the textual and iconographic allusions to the metonymic structure of fetishism signals that the image of seductive femininity – prepubescent or adult – is structured by the requirements of a masculine unconscious. To this highly charged imagery is appended the titular text, a column of words analogically fragmented which, like the partial images, discharges an emphatically sexual but nonetheless gnomic set of meanings. Insofar as these meanings are both "in" the image and "in" the [male] spectator, "in" the artist's manipulations and "in" the spectator's reconstruction of them, the boundaries between the exteriority of the media's manipulation of desire and the interiority that shapes the spectator's interpretive response to them are revealed as alarmingly permeable.

In one sense then, Lewis can be said to be exposing a form of spectatorial complicity; the lure of the image (an image whose *raison d'être* is the translation of desire to consumption) is inseparable from the spectator's investment in that lure. But what is the lure and what is the investment? What subject position is here being orchestrated and what spectator is being produced? Do the anarchic trajectories of unconscious desire obviate the ethical imperatives of a politics of the image? These are some of the questions *She Will Ride Her Skirt...* can be seen to generate, and the complexity of the work resides in the difficulty of answering them.

Collectively, both the questions and possible responses are organized around the issue of sexual difference, for Lewis' work is primarily concerned with visually anatomizing the mechanisms and determinations of fetishism in both its psychic and commodity manifestations. Just as *She Will Ride Her Skirt...* poses the question of complicity in the creation and interpellation of representations, so too does it elaborate a dialectic between the surface and what lies underneath, asking, in effect, "What is under the woman's skirt?" As Lewis has himself written, "underneath is everything and nothing," a formulation that again underscores the determinations of the patriarchal imaginary.[3]

On the other hand, the seduction of the commodity and the images manufactured to purvey its allure speak equally to male and female subjects. Thus, the seduction of the images that Lewis re-purveys are not exclusively the province of masculine fantasy and desire. In this respect, one is confronted with what Marx described as the commodity's "metaphysical subtleties and theological niceties,"[4] properties that are doubtless augmented by the image world which re-presents them. That Lewis' work so blatantly mimics the gloss and glamour of commodity culture, that it battens upon the commodity form in its manufacture and address, is a function of a political understanding but one that, in keeping with the bleakest analyses of postmodern culture, presumes no escape from the phantasmagoria it adumbrates.

NOTES

1 Louis Althusser, "Ideological State Apparatuses (Notes towards an Investigation)," LENIN AND PHILOSOPHY AND OTHER ESSAYS (New York: Monthly Review Press, 1971), 127—186.

2 Laura Lamb, exhibition review of BURNING at Artspeak Gallery, ARTERY (1987), 4.

3 Mark Lewis, "Victims in the Visible," C MAGAZINE (Winter 1989), 45—53.

4 Karl Marx, CAPITAL: A CRITIQUE OF POLITICAL ECONOMY (New York: The Modern Library, 1906), 81.

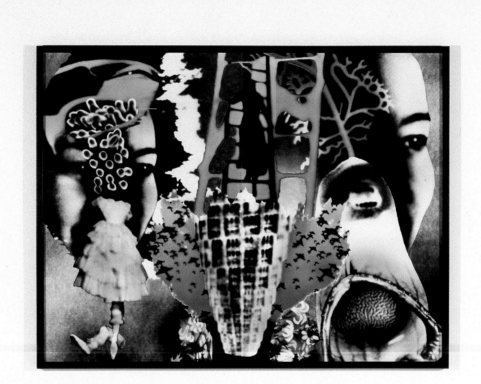

UNTITLED V, 1988–89. Black and white photographs, 1.55 m x 2.05 m. Collection: The Banff Centre.

Courtesy: Walter Phillips Gallery, Banff, Alberta. Photo: Monte Greenshields

In the Empire of the Gaze: Interiority and Abjection in Shelagh Alexander's Compilation Photographs

James D. Campbell

A constant alternation between time and its "truth," identity and its loss, history and that which produces it: that which remains extraphenomenal, outside the sign, beyond time. An impossible dialectic of two terms, a permanent alteration: never the one without the other. It is not certain that anyone here and now is capable of this. An analyst conscious of history and politics? A politician tuned into the unconscious? Or, perhaps, a woman....[1]

Julia Kristeva

Shelagh Alexander's compilation photographs offer varying points of accessibility. In this essay, I will discuss her work as a critical practice and summarize what I see as some of the important and pressing issues raised by her work, including: its critique of taxonomy and the male gaze, its innovative take on Freudian dream-work, and its interrogative relation to art photography. *Untitled V* (1988 – 89), in the collection of the Walter Phillips Gallery, will provide the salutary touchstone for these condensed reflections.

On a superficial level, Alexander's compilation photographs appear to represent the inherent irrationality of the unconscious mind. However, with sustained viewing, these

renderings can be recognized as conscious metaphors intended to serve the ends of a social critique. In her photomontages, Alexander proposes a deconstructive reading of "woman" as social construction and, as a necessary consequence of her own methodologies, implies an emergence of the repressed, *la femme* – woman – who becomes *une* – one – and thus gives birth to her radical alterity.[2]

Alexander's works articulate interior states through the medium of sundry found images – but if interiority seems an unspoken content, it is in fact a marker of this artist's ideological and social concerns. These found images hypostasize one by one a range of internalized biases, presuppositions and stereotypes in contemporary culture. Once collated and juxtaposed within the same frame, these images construct metaphorical states of mind, belief contexts and social codes in a beguiling palimpsest fraught with feverish dreams of selfhood, basal desire and the taxonomy of the gaze, all of which affect the interpretation of concrete, lived experiences. They also constitute, in Kristeva's words, a "constant alternation between time and its 'truth,' identity and its loss, history and that which produces it: that which remains extraphenomenal, outside the sign, beyond time."[3]

A photomontage by Alexander is rife with subversive signs that oscillate between wildly different foundational contexts; nevertheless they are interwoven in a culturally courageous expression of conscience within a postmodern art practice. Juxtaposing a fictional context, such as the Hollywood movie where "woman" is codified by the male gaze as object of desire, and an autobiographical context, such as the family photograph album where the artist eavesdrops on the process of herself becoming "woman," Alexander examines the hypocrisy of social norms and hurtful stereotypes at extremely close quarters.

Why does Alexander choose photomontage as her articulating medium? It may relate to the exigencies for a methodology of disclosure. Does it have to do with revealing a certain "knowledge and sometimes the truth itself about an otherwise repressed, nocturnal, secret and unconscious universe? Because it thus redoubles the social contract by exposing the unsaid, the uncanny?"[4] I think the answer is probably yes, for the photocompilation technique that Alexander uses so judiciously to yield a latter-day

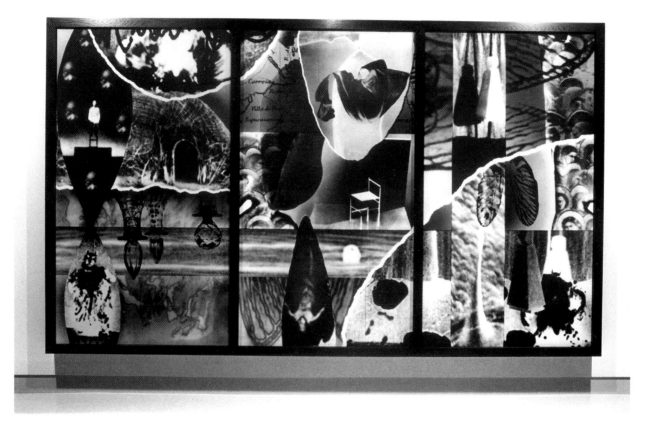

GHOST, 1991. Fibre-based gelatin silver selenium toned photographs, 2.2 m x 3.9 m x 15 cm framed. Collection: private.

Courtesy: the artist. Photo: David Kalef

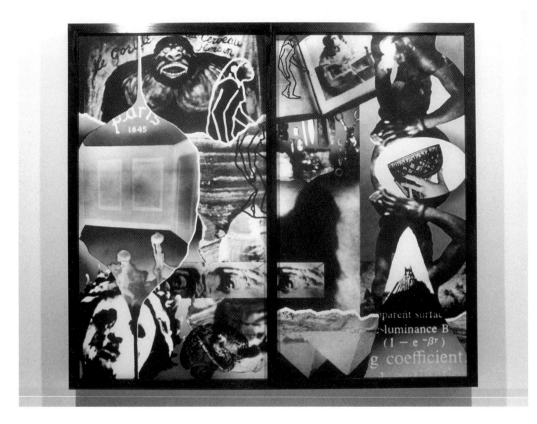

SPHINX, 1991. Fibre-based gelatin silver selenium toned photographs, 2.2 m x 2.6 m x 15 cm framed. Collection: private.

Courtesy: the artist. Photo: David Kalef

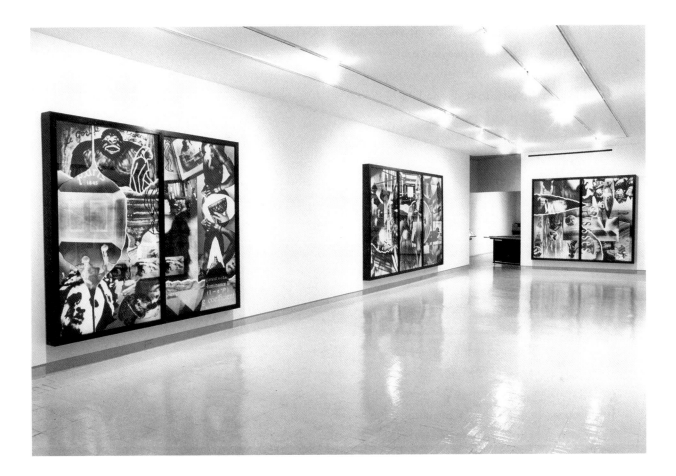

IMPERIAL CAFE (installation view), 1991. Fibre-based gelatin silver selenium toned photographs. Collection: the artist.

Courtesy: the artist. Photo: David Kalef

Hieronymous Bosch-like tableau is not governed by the identification of an explicit demonology but the indictment of concealed, causative stereotypical expectations that facilitate both difference and subjugation in contemporary society. In other words, their dissociative juxtapositions and sundered assumptive contexts reveal the true nature of *our* demonology, that is, one latent in cultural memory, historical fact, the unexamined presuppositions of sociality itself. This demonology constructs difference from the standpoint of the *many* – not the *one* – and is thus responsible for individual abasement.

Alexander has used Hollywood movie stills, family movies and snapshots, wire-service photographs and other "found" imagery in her work as a way of mining cultural norms for the raw ore of hypocrisy lying dormant but ineradicable (until exposed) in stereotyping and taxonomy. This repertoire of found images yields a plethora of social fabrications and a fugacious yet beguiling resonance of the unrepressed unconscious. The found images are transformed into a litany of fragmented objectivities, posed within a radically indeterminate space that points towards the travails of an abject subject/object. Culled from ruptured narrative refrains, and disrupted assumptive contexts, the images themselves constitute a condensed narrative structure that somehow eludes taxonomy. Alexander elides the laws of nondiscursive expressive form with discursive impulses that concomitantly animate that form, so that seemingly disjunctive images seem irrevocably conjoined in one collapsed narrative, the sutures of which are continually tested by but never succumb to internal tension.

Another aspect of Alexander's endeavour is the thematic contextualization and decontextualization of the photographic image. While the artist appropriates images, she also appropriates and critiques the methodology of compilation photography itself. The results can be interpreted as a subversive commentary on the traditional discourse of photography.

Alexander is not a photographer *per se* and thus her personal mediation of an existing reality does not reflect an autobiographical consciousness or "belief context" that would entail the pervasive presence of a *producing* author, authorial imprint or photographic "style." Alexander is interested, rather, in generating a context in which

the *doxa* of sociality and modernist values are themselves subject to examination, transgression and critique: her work is placed in an interrogative and therapeutic relation to art photography by appropriating and subverting conventions of photographic representation. Her incisive representational critique eclipses the claims of art photography to aesthetic truth and offer a relentless critique of a social condition that many would still, perhaps, prefer to ignore: the pertenacious hegemony of the male gaze in which woman is constructed as spectacle, as fetishized object. Alexander demonstrates the need for a deconstruction of this taxonomy and its subsequent subversion, if not rehabilitation.

The "fleshiness" that often informs the subject matter in Alexander's work and the references to corporeality may univocally suggest that the female subject is not to be interpreted as an unanchored, disembodied, disincarnate entity...but as a subject "only with reference to the mapping and signification of its own corporeality."[5] In this regard, it seems clear that Alexander the practising artist, like Kristeva the theorist, is fascinated by

> the ways in which "proper" sociality and subjectivity are based on the expulsion or exclusion of the improper, the unclean, and the disorderly elements of its corporeal existence that must be separated from its "clean and proper" self. The ability to take up a symbolic position as a social and speaking subject entails the disavowal of its modes of corporeality, especially those representing what is considered unacceptable, unclean or anti-social.[6]

Hence, Alexander's series *Voices of the Unclean* is in one conspicuous sense just that, giving voice to the repressed, "unclean" content referred to by Kristeva. What is disavowed in order to gain the "stable self" – precisely the destabilizing elements – are redeemed by Alexander in the name of the *daughter.* It is precisely that which the symbolic order represses that Alexander exposes in her deconstruction of the received order of imagery and the hegemony of the male gaze. Alexander's work evokes a sentiment expressed some years ago by French feminist Luce Irigaray: "What is at stake in the situation we are living at present is the language refused to our female body."[7]

The nature of this refusal is particularly transparent in the images Alexander has culled from the Hollywood film, stamped as such film is – and indelibly, too – with the name of the *father.*

On still another level, Alexander's collocations of images may be interpreted as simple miscellanies of dream fragments without, however, the attendant spectre of censorship. This is where the relevance of the Freudian dream-work to Alexander's endeavour can be found and her disavowal of Freudian phallocentrism made explicit. Her works are landscapes riven with surreal phantasms that seem to well up, in a seemingly arbitrary and disconnected but strangely unsettling way, from another place, another time (the Hollywood of the 1940s, old family photos). In Freud's dream-work, a comparison is made between the remembered manifest dream content and the latent dream thoughts, that is, the sum total of the transforming processes which have been responsible for the change from the latent to the manifest content. These processes, including condensation, displacement and representability, all have their counterparts in *Untitled V.* Yet, Freud's dream-work is a pretext for postulating a phantasmagoria, a dark carnival of the soul, that has its counterpart in the dream but is a marker of the "real," in that it represents "woman" as spectacle within the guise of the dream text. Reading between the lines, however, one can see the efficacy of the artist's critique, the inadequacy of the Freudian equation and the blind spot of its author.[8] These images deconstruct the Freudian dream-work through exposing its inherent phallocentrism. Here the paternal "law," the will to classify and subjugate, is subverted as it achieves manifestation. The surreal quality of colliding dream-like images as they form one seamless whole, haunted by the ethos of the dream-work and heightened by a strikingly effective methodology, serves as a valid pretext for exploring hidden presuppositions in social reality, including female devaluation through male-oriented ideology, sex-role stereotyping and masculine dread. She thus forcefully confronts the alienating and objectifying power of the "other's" gaze. Her process of compiling sundry images is truly an *aesthetic of disruption* that poetically assumes the guise of the Freudian dream-work only to subvert it from within to further her critique of the taxonomic gaze. And, if the manifest content of this work is akin to some dark fantasia of the unconscious, all

the better to draw unwary viewers into its narrative traps and have them glimpse, perhaps, mute Narcissus staring them back in the face. *Untitled V* in particular is a complex exemplar of deliberate association and dissociation as it wilfully deconstructs and conjoins the subject and those contexts in which the subject is constituted and subjugated. It is thus resonant with *identity* and *difference.*

Alexander's tableaux reveal the pervasive, staggering presence of the unconscious in the visual field, in the terrifying plenitude of its semiosis, in abstract conglomerations of imagery, illogical displacements of form, terrifying vortices of internalized representation. Perhaps the images are specifically unsettling because the tension between conscious (differentiated) and unconscious (undifferentiated) modes of thought is deliberately exacerbated, affording viewers no comfortable margin of solace or distance.

What seems to be the fetishized head of the dreaming or dreamt-of woman – perhaps an image lifted from a Hollywood film – is seemingly riven asunder to suggest a cornucopia from which flows Oedipal asymmetries and intrapsychic fantasies, a tableau in which there is no successive or linear time but one in which all tenses have collapsed together, forming one temporally homogenous mass within a fractured space which may be interpreted as the space of the unconscious. Both identity and difference are posited here but Alexander makes clear that it is social and political organization of gender at stake. It is thus a radically taxonomic space under treatment and one in which a specifically male gaze is seen as seeking to subsume and eradicate this identity *and* this difference. And thus the male gaze is so indicted.

Alexander's work represents "both a construction of new imagery and a critical deconstruction of received imagery," a mensurable pathology of the image.[9] As viewers, we gradually find ourselves reconstructing the work in a way that apprises us of the social fabrications that fructify in its found imagery. Images from another time and another space impinge upon present social and cultural time and space and, if viewers are sensitive to the transformative processes involved, the images have the capacity to alter social awareness. What for many must have once constituted a shared touchstone of a social reality – whether found in the Hollywood movie or the family photograph

album – becomes a subversive reality, a chiasmic intersection of signs.

In deconstructing the male gaze, Alexander is also deconstructing the scopic regime of modernity itself. Thus it is not only a phallocentrism that is exposed here, but the dangers of an ocularcentrism as well, provoking the inevitable question: are we *seen* or *seeing* here? Alexander's wilfully disruptive and often harrowing imagery is therapeutic in its critique of taxonomy when that taxonomy is synonymous with *visuality* and *death.* Alexander pits "being a woman" against the phallocentric syntax of the Hollywood film, and the message is conveyed unerringly that the male gaze, in its enervating taxonomy and relentless operations of cadaverization, is predestined to corrupt and destroy everything that it touches. Perhaps Alexander seeks, in a work like *Untitled V,* to deconstruct a "perverse world," which, according to Gilles Deleuze,

> is a world where the category of the necessary has completely replaced that of the possible: a strange Spinozism where oxygen is lacking replaced by a more elemental energy and a rarefied air....Every perversion is an othercide *(autruicide),* an altruicide, and so a murdering of possibles.[10]

It is precisely this *murdering of possibles* – the othercide so implicit a factum in the operations of the male gaze – that Alexander brings to manifestation and mourns after in her remarkable compilation photographs.

NOTES

1 Julia Kristeva, "About Chinese Women," in A KRISTEVA READER, ed. Toril Moi (New York: Columbia University Press, 1986),
 156.

2 Elisabeth Roudinesco, JACQUES LACAN & CO: A HISTORY OF PSYCHOANALYSIS IN FRANCE, 1925–1985, trans.
 Jeffrey Mehlman (Chicago: University of Chicago Press, 1990), 525.

3 Kristeva, 156.

4 Ibid., 207.

5 Elizabeth Gross, "The Body of Signification," in ABJECTION, MELANCHOLIA AND LOVE, ed. John Fletcher and Andrew
 Benjamin (London: Routledge, 1990), 85.

6 Ibid., 86.

7 Luce Irigaray, cited in Roudinesco, 525.

8 For an intriguing treatment of Freud's fallibility, see Françoise Meltzer, "Descartes' Dreams and Freud's Failure, or, The
 Politics of Originality," in THE TRIAL(S) OF PSYCHOANALYSIS, ed. Françoise Meltzer (Chicago: University of Chicago
 Press, 1988), 81–103.

9 Philip Monk, SUBJECTS IN PICTURES (Toronto: YYZ, 1984), 17.

10 Gilles Deleuze, "Michel Tournier and the World without Others," in IDEOLOGICAL REPRESENTATION AND POWER IN
 SOCIAL RELATIONS, ed. Mike Gane (London: Routledge, 1989), 135.

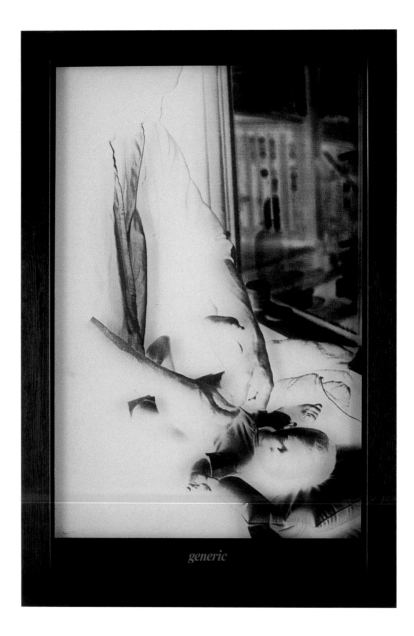

generic

GENERIC, 1988. Black and white mylar transparency with colour text, 1.7 m x 1.2 m.

Collection: The Banff Centre. Courtesy: Walter Phillips Gallery, Banff, Alberta.

Photo: Monte Greenshields

Encountering Photographs:
Kati Campbell's *generic*

Donna Zapf

The face is blurred. The body is a woman's, childhood a fading map still slightly legible in the way of young adulthood in western culture. Vulnerably unfinished she tips from the stairs and dissolves into contrasts and grey tones.

My landlady, Dores, snapped a photo of me in front of the Pendrith Street rowhouse above Christie Pits. It was a Saturday in 1973. Joachim, her son, was pushing at his mother's knees. "I hate you Mama. I kill you, I kill you." He made an explosive sound. The camera had moved. Or maybe the surface of time had rippled over the delusion of taking the world whole.

A picture is worth a thousand words. A modern adage, a thought worth pursuing in a world given over to visuality. Most of us do not get through the day without encountering photographs.

In thinking about Kati Campbell's *generic,* I was struck by the obvious: the use of photography in the piece itself, in fact, throughout Campbell's work, and the pervasive presence of photography within recent art practice. One astute yet crucially limited analysis of photography in relation to art practice is Rosalind Krauss' article, "A Note on Photography and the Simulacral."[1] Within a multivalent argument, Krauss points out that the photograph's "technical existence as a multiple" disqualifies it as an aesthetic object "within the aesthetic universe of differentiation" in as much as the photograph cannot aspire to aesthetic differentiation ("which is to say: 'this is good, this is bad, this, in its absolute originality, is different from that'").[2] As a result, Krauss claims, the photograph fails as an art object and, simultaneously, deconstructs the aesthetic

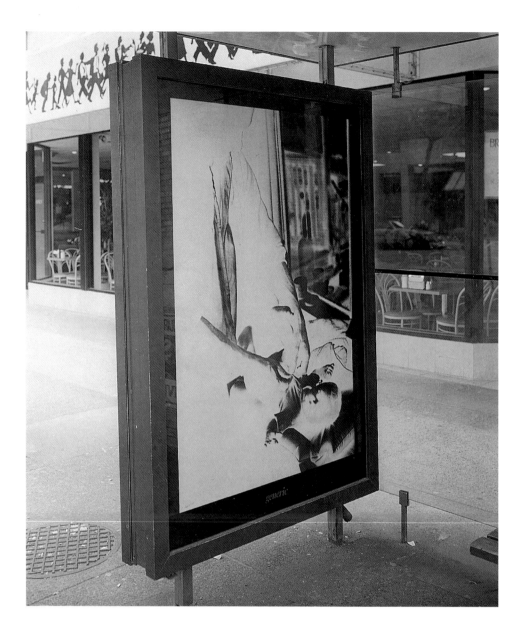

GENERIC (installation view), 1988. Black and white mylar transparency with colour text.

Collection: The Banff Centre. Courtesy: the artist. Photo: Don Gill/Warren Murfitt

premises that support the art object. Using the work of Cindy Sherman, Krauss affirms photography as important to art practice only insofar as it does not aspire to being art.

> [Sherman] understood photography as the Other of art, the desire of art in our time. Thus her use of photography does not construct an object for art criticism but constitutes an act of such criticism. It constructs of photography itself a metalanguage with which to operate on the mythogrammatical field of art exploring, at one and the same time, the myths of creativity and artistic vision, and the innocence, primacy, and autonomy of the "support" for the aesthetic image.[3]

Krauss' analysis of the innate deconstructive propensities of photography in relation to modernist art practice is important in a consideration of the use of photography in recent art practice. However, I am troubled by its limitations. In order to align the critical fate of photography with the deconstructive paradigm, Krauss positions photography outside of art practice. If, however, it is considered as not separate from, but part of, contemporary art discourse, as in the work of Kati Campbell, Krauss' construction creates a solipsism in which the art object exists solely to deconstruct and critique its own existence. This solipsism limits the possibilities for the art object to be more than a body built of linguistic strategies. The issues surrounding photographic representation, however, shift when photography is considered in relation to art practices other than modernist. Why, for example, is photography such an important component in an art field much concerned with issues of identity and subjectivity? But further, if photography is repositioned within art, a comparable shift in critical discourse is necessary to accommodate the discussion of the *subjects* of the work: the artist, the subject constructed by the work and the subject who engages with the work.

When I consider the issues of subject and subjectivity in relation to photography, I become interested in the photographic practices that Krauss proposes as "other" to deconstructive photographic discourse. She cites, for example, *Une minute pour une image*, a television series by French filmmaker Agnes Varda,[4] in which each one-minute segment consisted of a photograph with a voice-over commentary. For Krauss, these commentaries demonstrate a populist response to photography, the compulsive attempt to describe the image, to provide an anecdote: the litany of, "it's this, or this, or this, or

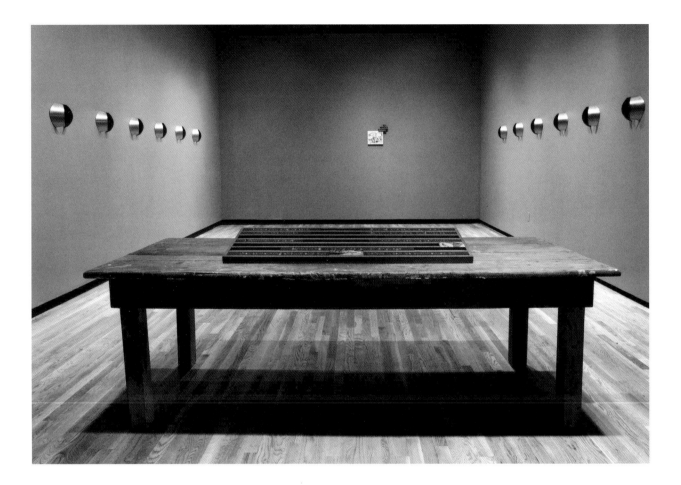

SYMPTOM (installation view), 1990. Hand-incised metal foil on wood, lead, cold rolled steel, screened aluminium, chrome

etched aluminium, wood table. Collection: the artist. Courtesy: the artist. Photo: Monte Greenshields

maybe this." Krauss terms this response "primitive."[5] In stressing the apparently populist desire to add language to the photograph, however, Krauss inadvertently gives a clue to the condition of photography most useful to recent art practice, the particular mechanisms of subjective participation with the photographic image.

I am looking at a reproduction of Kati Campbell's generic, *remembering it in its first installation, an advertising panel in a Vancouver bus shelter. I am searching for memory of my initial response: a vague recognition of being pulled into the piece with a curiosity, then an urgency that traced the faultline of photographic response that Krauss disparages in her essay – the "primitive" need to describe...patterns of blacks and greys on surface,...a photograph,...a photographic negative. Then a desire to speak what it is – the whole captioned by a green, lower-case word, "generic" – a confrontation.*

How is photography the "other," the desire of art? Within this metaphoric paradigm, art becomes the imaginary unitary self who desires a projected image of its own incompleteness and fragmentation. As defined within modernism, art is self-sufficient, integral, complete within itself, non-contingent, not repeatable. Photography, however, is paradoxical. It both asserts and reveals as ideology the epistemic system that frames it. As an indexical sign, photography presents the promise that it is the world held as trace. But this truth exists only within the epistemology of western technological society. Photography creates the effect necessary for objectivity: it proposes the absent subject. As an object of technology, photography promises a technological utopia, an apparently pure trace of the world, separate from subjectivity such that the image itself is a metaphor of the technological paradigm: the epistemological construction of an empowered self separate from a world available to empirical knowledge. But the photograph is also the site of an inherent and disturbing resistance to this technological epistemology. What the photograph paradoxically shows is the impossibility of that objective reality. We perceive the world as embodied selves, the machine records merely an image, never experience or memory.

Confronting a photograph that is not contextualized by language is like confronting a vacuity, a space to which we desire to connect ourselves. We provide the image with context, a narrative. And through language we confirm this seemingly unnamed trace of

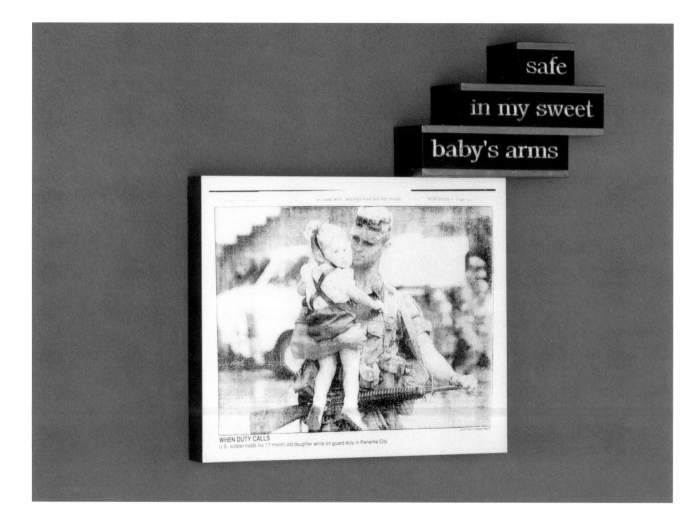

SYMPTOM (detail), 1990. Hand-incised metal foil on wood, lead, cold rolled steel, screened aluminium, chrome etched aluminium, wood table, 10.8 m x 4.7 m x 3.2 m. Collection: the artist. Courtesy: the artist. Photo: Monte Greenshields

the world as part of the symbolic order, as part of what is already known to us. This desire, while in itself conservative, also makes visible (whether or not it is acknowledged) the subjective intervention in the making of the image. As well, the anecdotal response returns psychological depth to the flat surface of the photograph.

I desired to read generic, *to find the story. A man is dressing a child. He focuses intensely on the child whose rapt gaze is directed out of the image, toward the photographer or the viewer, myself. Where is the mother? Is she the photographer, the recipient of the child's passionate address? Does this then place me in the position of the mother as the crucial third term, the actor in the wings?*

The lure of *generic* for me is effected by its set up of this "anecdotal desire," its acknowledgement of photography's promise and failure. It is this nexus of promise, desire and failure that effects the "hallucinatory condition of advertising"[6] that Campbell self-consciously engages. In the case of *generic,* the impossible promise of the photograph as a "truth" is engaged in the critique of the naturalized construction of gender. The positioning of a man rather than a woman with the child, however, reverses the socially inscribed and stereotypical expectation that would characterize the smooth apparatus of advertising. It reveals the ideological apparatus operative through photography. The image is presented as a negative, a reversal in the mechanical process which overdetermines the gender reversal. The negative in guise of an x-ray also ironically references the ideology of technology: the machine extends and perfects the body, probes the inaccessible interior, sees what the eye cannot.

The caption "generic" pursues the ambiguity of the image. It suggests that for a man to care for a child is a natural – a generic – practice.

[Campbell describes *generic* as] a negative transparency of a man parenting as a metaphor for his "becoming" woman. The ideology of representation uses narrative constructs to locate fathering at the periphery of "real" parenting, i.e. mothering. His duality is accommodated only to the degree that his parenting is exceptional, is in excess of his (normative) public identity.[7]

The caption "generic" is also a pun that references generation within the image (father and child), the reproductive photographic machine and the notion of genre within the making of representation or within historical art practice. In the latter inflection, the gender reversal is a witty reminder that there is no genre of father and child, as there is of mother and child in Christian iconography, for example, or genre painting of the eighteenth century.

Significantly, when Campbell reconstructs *generic* for a different public space, the gallery, she engages the discourses and history of art practices signified by the gallery space itself. The negative transparency floats on the surface of a black box, self-consciously an art *object* installed on the wall of the gallery. The object is ambiguous: a frame for the image, an advertising panel, a negative carrier, an x-ray light box. The composite assemblage allows a passage from art into everyday practices and back, via the subjective engagement of the spectator.

Writer and critic Jeanne Randolph suggests in her essay "Influencing Machines"[8] that a "found object" may be an object (or an idea, image, practice, tradition and so on) that is recouped and repositioned within the artwork such that our experience is also renewed. Campbell's *generic* incorporates technology as a "found object" and in so doing shifts our perception of technology. It is within the discussions of the subjectivities of the art object that Krauss' deconstructive paradigm is revealed as most limited. It is through the consideration of subjectivity as well, however, that other approaches to art are possible. Randolph has suggested the consideration of the art object as an "amenable object,"[9] one that invites the subjectivity of the spectator. Her inquiry into the art object and its discourse uses the "object relations" aspect of psychoanalytic theory through the particular work of D. W. Winnicott: "[I]n art it is the ambiguity between the objective and subjective that gives artworks a unique psychoanalytic validity....[T]he model of the art object is that of an object amenable to an interaction with the viewer...."[10] This encounter with the artwork moves beyond the deconstructive paradigm. It premises the possibility that, in subjective interaction, the artwork can effect a change in perception. The lateral play of subject and object defines a third space of culture that belies the absolute separation of subject and object necessary to a technological explanation of the world. This approach to art practice

SENSOR, 1990. Gloss enamel on medex, 1.8 m x 1.1 m x 1 m. Collection: the artist.

Courtesy: the artist. Photo: Monte Greenshields

removes the modernist frame which is the subtext of Krauss' article. I would also like to extend the possibility that photography's particular engagement of subjectivity allows it a special propensity to being positioned as an amenable object.

The utopian aspiration of the amenable object with its focus on the subjects of art finds a parallel in Campbell's equally utopian proposal of the transformative potential of the subject:

> What I find myself trying to do is reconstitute from advertising's maw the originary subject, knowing that there is, in fact, no such entity. Subjectivity is socially and ideologically constructed. Still, there remains, blasphemously, despite the hyper-mediations of commodity fetishism, of patriarchal maintenance, a person who originally was posed and incorporated in the "shot," a body inscribed. This is what it means to be raised into the symbolic. I am interested in the idea of reconstituting that body, removing the text and the terrain which expunges that possible self, of de-signifying and returning to personal integrity, the body away from spectacle.[11]

It is, then, significant that *generic,* a work complexly constructed in relation to subjectivity, should include photography as a central aspect. Photography reveals the machine at the core of its production. It also exposes the dangerous illusion of the epistemological paradigm that requires that we vacate our bodies and trust the monstrous construct, the disembodied eye.

NOTES

1 Rosalind Krauss, "A Note on Photography and the Simulacral," in THE CRITICAL IMAGE: ESSAYS ON CONTEMPORARY
 PHOTOGRAPHY, ed. Carol Squires (Seattle: Bay Press, 1990), 15–27.

2 Ibid., 21.

3 Ibid., 27.

4 For a description of the series and translations of some of the commentaries, see Krauss, 15–18.

5 Ibid., 17.

6 Kati Campbell, artist's statement in the catalogue for IDENTITY/IDENTITIES: AN EXPLORATION OF THE CONCEPT OF
 FEMALE IDENTITY IN CONTEMPORARY SOCIETY, curated by Shirley J. R. Madill (Winnipeg: Winnipeg Art Gallery, 1988),
 10. The actual quotation is, "Advertising is the hallucinatory condition of our age."

7 Ibid., 10.

8 The ideas in this section are deeply indebted to the writings of Jeanne Randolph, in particular, "The Amenable Object," and
 "Influencing Machines: The Relationship between Art and Technology," PSYCHOANALYSIS & SYNCHRONIZED SWIMMING
 AND OTHER WRITINGS ON ART (Toronto: YYZ Books, 1991).

9 Randolph, "The Amenable Object," 21.

10 Ibid., 26.

11 Campbell, 10.

PARADE, 1986. 4 silver prints, 74 cm x 80 cm each. Collection: The Banff Centre. Courtesy: Walter Phillips Gallery, Banff,

Alberta. Photo: Monte Greenshields

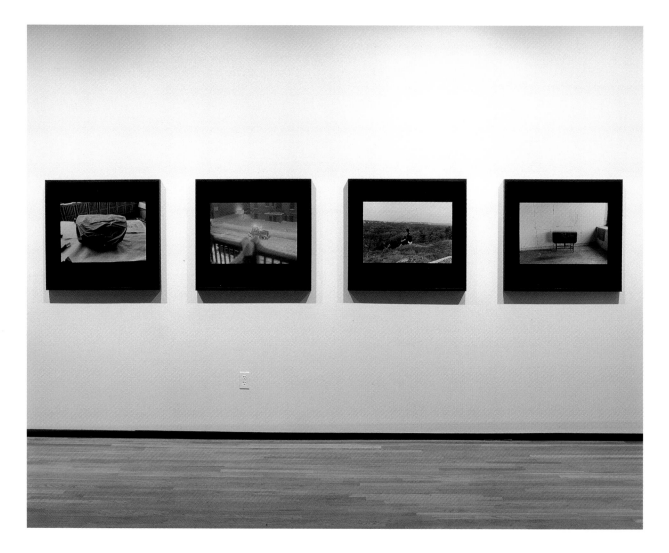

PARADE, 1986. 4 silver prints, 74 cm x 80 cm each. Collection: The Banff Centre. Courtesy: Walter Phillips Gallery, Banff,

Alberta. Photo: Monte Greenshields

Reflecting upon this Landscape: The Imagery of Raymonde April

Richard Baillargeon

> This water of rivers you touch
> the last of waters that were
> the first of waters to come —
> time present
>
> Leonardo da Vinci[1]

To hold life on the surface of photographic paper. To wager that this piece of paper will contain a truth, one that is relative, partial and existential, but a truth nonetheless. A truth in and for itself, one lacking any authoritative value, and not intended to convince or to serve as proof. Photographs that are not photographs, although they do assume photographic traits. Photographs that have the fluidity of things, time, perception, that are extremely fragile, at the mercy of the winds. Such are the photographs of Raymonde April. From one work to another, they form a complex chain that, like an echo, tirelessly comes back upon the perimeter and periphery of these individual and inevitably partial truths. And these are truths which remain at far remove from moralist velleities and from the great politicizing and militant imperatives. Her work would ultimately be a mechanics of vision, speech and language, of the entanglements of meaning.

Parade, dated 1986, contains four images: a typewriter partially concealed under a dust cover, a snow-clearing vehicle at night, a figure (the artist) in the middle of a blurry landscape, a leaf table against a wall. Each thing is unique, remarkably individualized, centralized in fact – if this can be predicated of a thing placed in a middle position – as if it were a matter of monopolizing the attention of something eminently important, sacred almost. A ritual perhaps. A device that conjures up yet another, summons up something distant, buried in memory. The repositories, altars of repose. We had them when I was a child. They were part of Catholicism, were used to house God in another location, outside the church. They were usually associated with displays of splendour. Someplace late in the spring. In Québec and Rivière-du-Loup, we looked on them admiringly, almost dumbfounded. Here, however, the repositories are pagan, secular.

Raymonde April's repositories have nothing luxurious or ostentatious about them. They seem, instead, to affirm only the facticity of what lies at the centre, the reality of what is available to the gaze there, prominent, in the middle. They are images not of power or the untouchable, but rather of the vulnerable and fragile. Within the black outline of a large frame, in the dark room (like the one that serves to capture light on photographic film) we encounter – captured, there – things and a figure. Images, tableaux that relate to the fact of being medial, to what is only, beyond all other considerations, a centre at its centre – this position in the middle, fragile and otherwise mute. Raymonde April has made us accustomed to such things. By this I mean that, until now, April's art has made no place for what is literally an obvious meaning, for anything that might be taken at face value. It is an art of the unspoken, of things barely touched upon, that would dissolve upon stronger contact, because they are fragile, as are the things of this life.

Words, images, have accidently slipped their moorings, drifted off to ultimately flounder in unknown regions. They have plunged, in the full sense of the term, into the depths of a sea whose surface is deceptively calm. For words and images take curious detours, ones that take them far beneath the surface.

Careful, warning – it could also be called a parade. For a *défilement*[2] (progression) or

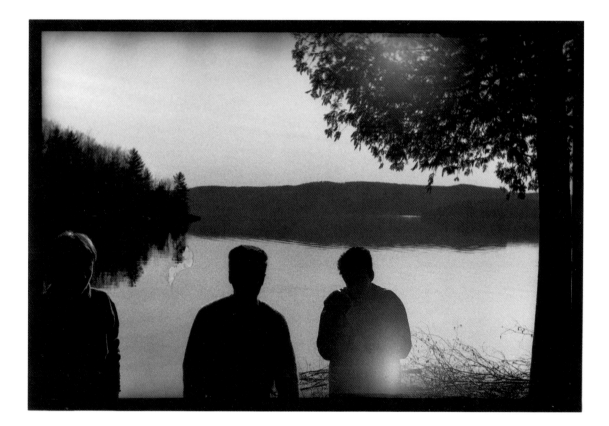

CABANES DANS LE CIEL (1 in a series of 25), 1984–85. Black and white photograph, 50.8 cm x 76.2 cm. Collection: the artist. Courtesy: the artist. Photo: Raymonde April

défilé (procession) is also a parade. A curious reversal. I watch images slipping, slipping by, I see drawers opening. Opening and closing. In go old postcards, out come white rabbits. Time is pushed in, small framed fragments slide out. It makes (or could make) no difference, since entering or leaving is merely a function of one's point of view.

WAR

One would almost have to speak of images. Better still, of *the image.* Because images are, in the end, what Raymonde April does.

One watched parades from the balcony. One day, a long time ago, there were soldiers. I remember the leaden sun, the helmets, all the khaki. The helmets stretched back as far as the eye could see. Their movement created waves, a green muddied ocean. They came down the hill. It was hot, too hot. The Korean War. Image of images. She sees the snow-clearing vehicle from the balcony. A spectacle. Evening. One day she spoke of Musil. Of *The Man without Qualities.* Not really about him, about Musil, but about what he wrote. She actually used a few passages. Like this one:

> Agatha believed that all true still lifes could arouse this inexhaustible and joyful sadness. The longer you looked at them, the more it seemed that the objects depicted therein were standing on the florid shore of life, the eyes filled up with immensity and the tongue paralyzed.[3]

To suggest what she sees in these images, in their components. Their material which, paradoxically, is impalpable. Never present, it never ceases to haunt us. *Time* could be another name for it. The impalpable, the almost unnamable. You would really like to believe in images, see them as true and just. Yet you know full well that most of the time they fall apart. For a time it seemed that photography, in its beginnings at least, might have provided the means to halt slippage once and for all. Yet later it turned out that it did no such thing. Slippage continued, it was inevitable. Go with the flow or, rather, admit that this is the way it is, that there's nothing you can do about it, you have to go on.

The snow plough in the night. It had snowed earlier. It may have snowed all day

Sunday. Snow everywhere. Not a storm or a blizzard, just banks of snow everywhere, for hours on end, all day long. Night fell and it was still snowing. You told yourself that if it kept up, by tomorrow everything would be closed, checked by snow. But late that evening, before going to bed, you looked out the window. There were only a few flakes falling. It was over, then. Piles and piles of snow. White, immaculate, lending the night a strange luminescence. Then you heard the noise of the plough. People resurfaced. It was a pity, because for a moment there you believed that humans and machines had disappeared for good.

THE ORDINARY

The work of Raymonde April takes place in the gaps of time. It ceaselessly surveys and charts the highly contemporary notion of presence/absence. It is continually overflowing the sensible, too narrow frames of photographs. Something in it is always pointing to an elsewhere beyond the frame. Difficult to say where exactly. It is an indefinable *hors-champ*[4] that I, as a viewer, can choose to fill – as long as I pay attention to it, as long as I stop to ponder. Then, I hear noises, sounds not audible on the surface of the paper. Or music, vaguely sad. Cupping my ear and looking beyond the texture of the paper, I may also hear the murmur of the wind and the streets. Ordinary things, the sounds of life. Things that are simple, though never banal.

I can, however, fill this *hors-champ* with other things. With ideas, thoughts. Already a more complex architecture would begin to take shape. The image within, the image without. Ultimately, the image may be of no importance. Perhaps that is why it must be dissolved inside a large black frame. Because that is the way things work: the centrality apparent at the heart of the black points to a sort of interchangeable quality in the elements. This is, perhaps, the root of what we call metaphor, the image of the image, this break in the black covering an object, like the gaze that slides off and gets lost. A gaze that collides with the surface of an object only to bounce back onto another.

In a recent text, Raymonde April wrote: "I want to construct fictions based on authentic elements. I only work with what I know well, in an infinite microcosm that I multiply to infinity to furnish a galactic space."[5] Working the ordinary, it could be

LES FEUILLES MORTES, 1990. Black and white photograph, 1.83 m x 1.22 m. Collection: the artist.

Courtesy: the artist. Photo: Raymonde April

called. Working on things you know well, on things you are close to. The gaze directed on the gaze. And further on the artist adds: "I do not want to appropriate what I know nothing about. Nevertheless, I do not want to fabricate a personal history."[6] It is not a matter of the personal, only of the intimate. And it could be said that only through such intimacy is it possible to connect with the work and break through its *hors-champ*.

THE TABLES

A folding table against a wall, the fourth and last image of *Parade*, seems to be a reversal of the first image, the partially covered typewriter that one could, without too great a risk of error, imagine as resting on a table. But a table that cannot be seen, that can only be imagined. One that is absent but replete with meaning. Opposed to, in the final image, one that is empty but eminently present. Between the two, a game of mirrors in the negative.

The typewriter, a writing tool. In the other image, a tabula rasa, a possible space for writing. But a place for fiction as well. *Hors-champ*. The table: a singular, recurring motif. One sometimes has the feeling that this is one of the most remarkable recurrences in visual art today. The table as domestic site, as a territory shared in turn by the individual, the social and the sacred. Here, it is inevitably the territory of the intimate. The site of all (or nearly all) our investments in existence, the place where all things return, the airy support for all quills and typewriters.

THE LANDSCAPE

Elsewhere she wrote: "I always work with my own image, photographing myself alone. Then I photograph everything around me, everything that means something, all that happens. And I have my friends pose for me. Some of them take pictures of me, which I keep with the others."[7] She is there, in the landscape. She is the one looking far into the distance at something we cannot see. She has been photographed this way. Looking at this image, I think of another. She wrote: "I am profoundly moved by the differences of scale, by the boundless perspectives, and I feel that I am living in a

DE L'AUTRE CÔTÉ DES BAISERS (1 in a series of 14), 1985. Black and white photograph, 41 cm x 51 cm. Collection: the artist.

Courtesy: the artist. Photo: Raymonde April

UNE MOUCHE AU PARADIS (3rd of 4 photographs), 1988. Black and white photograph, 1.2 m x 1.7 m. Collection: the artist.

Courtesy: the artist. Photo: Raymonde April

romantic painting, with an ocean of mist at my feet."[8] The painting by Caspar David Friedrich should be familiar to most. Painted in 1818, it is almost a photograph in the age before photography. It shows a standing man from behind. From a high peak, he overlooks mountain tops emerging from mist. The time could be morning, just after sunrise. It is clear from his posture that the man is looking far into the distance. The landscape stretches away before him. His gaze is lost among the mountains. As in Raymonde April's picture, where she occupies a similar position. It is a curious, indeed a strange device, that has me observe a figure that, in turn, is observing. My gaze wants to follow a gaze that I do not see, but that I can envision and imagine. It is a device that almost enables me to put myself in the other's place, become that other, slip into another's skin, use my imagination, let the fiction take off, inhabit the *hors-champ*. The landscape exists no longer; it has become lost in the paper, in time. A two-way mirror, a lure or a knowing subterfuge aimed at thrusting me literally into the arms of another illusion.

THE FALLS

The landscape has disappeared. Or it is no longer possible unless you think about the one who saw it, who would have been struck by it, who will see it. Only another site of the gaze, another of its avatars. The photograph yields, retreats. It embarks, take us with it as long as we are willing to lend credence to its fiction. Another parade, another procession.

She wrote, "I prefer to think of them as expressing a photographic present, a never-ending now that lives on in my favourite images, within a space that is theirs alone."[9] Cascading waters.

NOTES

1 Leonardo da Vinci, OMBRE LOINTAINE, trans. and with intro. by Franc Ducros (Aix-en-provence: Alinea, 1983), 6.

2 Translator's note: The author is playing on the polysemy of the verb *défiler*. In addition to the action of parading (recalling the title of the work in question), the verb can indicate the streaming by of images or memories in consciousness or (in its reflexive form) echoing the immediately preceding trope of words and images that have slipped their moorings, the breaking, the unthreading of a necklace or string of pearls.

3 Raymonde April, VOYAGE DANS LE MONDE DES CHOSES (Montréal: Musée d'art contemporain de Montréal, 1986), 43. Translator's note: The translation here from the French is from Robert Musil, L'HOMME SANS QUALITÉ, vol. 2 (Paris: Éditions du Seuil, coll. Points, 1982), 531.

4 Translator's note: The hors-champ is the off-screen space, in the mind of the viewer, of what is available to the gaze.

5 April, NEW BORDERS, NEW BOUNDARIES/NOUVELLES FRONTIÈRES, NOUVELLES DÉMARCATIONS, trans. Jeanluc Svoboda (Toronto: Gallery 44, 1991). Not paginated.

6 Ibid.

7 April, VOYAGE, 44.

8 April, "A Fly in Paradise," in THIRTEEN ESSAYS ON PHOTOGRAPHY (Ottawa: Canadian Museum of Contemporary Photography, 1990), 197.

9 Ibid., 196.

TRANSLATED FROM FRENCH BY DON MCGRATH.

CONSTRUCTION SITE AND SUNTOWER, VANCOUVER (1 in edition of 10), 1992. C-print, 41 cm x 51 cm.

Collection: Canada Council Art Bank, Ottawa, Ontario. Courtesy: the artist. Photo: Roy Arden

The Archaeology of Copper:
Roy Arden's WEST

Serge Bérard

> The true American dimension, to which the peoples of this continent are still inviting us today, is neither English, nor French, nor Indian, nor Inuit; it stems from the native conception of the Great Circle, according to which the obsessive respect for the specificity of each link of the chain becomes the essential condition for preserving the whole. We no longer have the choice; it is in this America that we must seriously think of landing, at long last....[1]

You walk through the halls of the gallery and suddenly you catch a glimpse of your own distorted face, bathed in the golden hue of polished copper. You lean forward and your gaze seems to sink in, just as a thousand rails have burrowed into the marshes of the Canadian west, into the photographic image of an accident, a train derailment, an immense display of steel, a piece of wreckage at the bottom of the ocean, so far from the sun that a greenish light, the colour of oxidized copper, just barely filters through, as if to go against the "intact purity" of the gleaming surface which is now beckoning you.

In 1808, for the first time in history, a locomotive suggestively named Catch-Me-Who-Can carries a group of *homo œconomicus* on a circular rail. It is powered by a steam engine which, as Michel Serres points out, represents a new paradigm: the world is no longer static, it undergoes changes, matter is transformation, mechanics become thermodynamics.[2] The locomotive is making huge smoke rings under the astounded

gaze of the dignitaries: circles as in "oncle" (uncle), my uncle on the maternal side, divine uncle,[3] Uncle Sam, wealthy uncle (but also, to "cry uncle"), the west. Because of the movement of steel on steel, the locomotive will soon bring with it all of the characteristics of modernity. It will revolutionize commercial exchanges and industrial production while heralding the coming forms of centralization: from its inception, the railway will only accept on its tracks its own vehicles driven by its own personnel. The rail stretches out rapidly, thus creating the tourist industry – visits to museums and galleries for example. In 1877, in the United States, railway workers will launch the first general strike in the western world, which will very nearly turn into a revolution: one hundred thousand strikers.[4] In Canada, the railway will embody the dream of a country extending from east to west, it will serve as currency for the integration of British Columbia in confederation and allow the white race to accelerate its domination over the entire territory of North America. The train is the, already ancient, history of modernity; to represent it is to make a historical painting.

It is during the last moments of the conquest of the rail in Canada, around 1880, that Franz Boas published his works on the Kwakiutl, a culture established along the northwest coast of North America. The abundance of natural resources allowed the development of a social and ceremonial life, the complexity of which is comparable to the medieval period in Europe. The Kwakiutl society, evaluated at approximately ten thousand individuals around 1835, and having already dwindled to three thousand at the time of Boas' study, is divided into twenty-five autonomous tribes. It is also extremely hierarchical: the structure of subordination first applies to the tribes and then, within each tribe, to kinship groups and, further, within each of these groups, to the individuals themselves. The assigned roles are passed on from one generation to the next, the most important (leading to the chieftainship) comes to the eldest son, the second in importance to the second son, and so on. It is as if, in the midst of such abundance, it had been necessary to create scarcity, a lack.

The chiefs occupy the position of power, the others constitute the ordinary world, society. Among the chiefs of the clan, the hierarchy or social status is established during the potlach when, in the midst of feast, chanting and dancing and the handing out of gifts, social rank is conferred upon the children. When it is the chief's turn to be the

...pper-plated steel, wooden frames, 84 cm x 53 cm each. Collection: The Banff Centre. Courtesy: Walter Phillips Gallery, Banff, Alberta. Photo: Monte Greenshields

Negative #42992. Photo: H. I. Smith - **FORT RUPERT POTLACH**, 1898. Courtesy: Department Library Services,

American Museum of Natural History

LANDFILL – RICHMOND, B.C. (1 in edition of 10), 1991. C-print, 41 cm x 51 cm. Collection: Canada Council Art Bank.

Courtesy: the artist. Photo: Roy Arden

W E S T, 1988. 6 diptych panels, hand-tinted black and white silver prints, c

host, he tries to be more generous than the previous host in his distribution of gifts, all this in an effort to lower the prestige of the previous host and at the same time enhance his own. In its most extreme form, in order to show that he has more than he needs, a chief will throw away to sea, in a supreme gesture of affirmation of his prestige and wealth, the most prestigious item of the potlach – the copper shield ornamented with emblems of his clan, which sometimes breaks into pieces upon impact. Offering the appearance of generosity, the potlach, a veritable merchandise war, is founded on rivalry and antagonism.

By juxtaposing the train and copper, Roy Arden is telling us of the shock of two cultures, of the conquering west and the conquered west; of the practice of colonialism which, in 1884, collided with the practice of potlach. Potlaching became illegal by governmental decree and punishable by imprisonment. This ban was lifted in 1951. During this period, the goods exchanged during illegally held potlaches were sometimes confiscated and this included the coppers, some of which were sold, without any authorization, to American museums.

An example of local history: masks and other objects were seized in 1922 by a civil servant in Indian Affairs, Mr. Halliday, who was the representative of the legal guardian; objects were preserved in the basement of the National Gallery of Canada until 1963 when James Sewid, Chief of the Council of the Nimpkish Band, went to Ottawa to reclaim their ownership. Once there, he was first told that the objects had originally been bought for the sum of fourteen hundred dollars. Sewid answered that no one had ever received this money; then, he took out his cheque book offering to reimburse the government for the fourteen hundred dollars in order to bring these objects back to his people. He was told that his money could not be accepted. Sewid had to appear on the national English-speaking television network to inform the public about this. Finally, after two or three visits to Ottawa, restitution was agreed upon, under these two conditions: that the Nimpkish Band build a fireproof museum and that the items not go back to individuals, since the Canadian government was afraid that these goods might be sold outside of Canada.[5]

What motivated the banning of potlaching was the shock between two conceptions of the economy. The obsession with ownership in the liberal west made it impossible,

during both the eighteenth and nineteenth centuries and until the New Deal was struck, to elaborate a conception of human rights. Should we then wonder at the fact that the white man could find the practice of potlach objectionable? The apparently gratuitous offering or, worse, the destruction of large quantities of goods (even according to the European standards of the time) would seem irrational, truly surrealistic: we can imagine his surprise at the sight of an Indian chief forcing an encounter between a sewing machine, a luxury item, and the indifferent sea. The banning of the potlach is perhaps an unconscious manifestation of the white man's fear because, for western ideology, the potlach represents the ultimate sacrilege.

It is, therefore, a physically, economically and symbolically devastated system that Boas would have studied. In fact, the repression of the potlach represents, beyond a contempt of non-western cultures, beyond racism, the usual contempt felt for "ordinary people" by those in power or with money. "Money is to the West, what kinship is to the Rest," Marshall Sahlins used to say, adding,

> it is the nexus that assimilates every other relation to standing in production. Money greed, or mania for wealth necessarily brings with it the decline and fall of the ancient communities. Hence it is the antithesis to them. It is itself the community...and cannot tolerate none other standing above it.[6]

In his practice, Roy Arden seems to be developing a representation of the political question in art, shifting the usual emphasis placed on the influence of collective representations of consciousness in order to focus on real past events. As a result the artist's tragic tone does not express a fatalistic pessimism that would imply an insurmountable flaw in contemporary consciousness but rather it offers a perceptive glance of a *fait accompli.*

In the west, still turned towards the east which echoes back like some kind of eternal return, we are surprised to see how the modern state has developed more and more horizontally. Copper is also of course the penny; it is the nominalist/realist debate resolved, in the universal sphere, that is. In the world market, its nominal value and its real content have very little to do with each other.

NOTES

1 Rémi Savard, DESTINS D'AMÉRIQUES (Montréal: L'Hexagone, 1979).

2 Michel Serres, "Turner traduit Canor," HERMES III (Paris: Éditions de Minuit, 1974).

3 Claude Lévi-Strauss, ANTHROPOLOGIE STRUCTURALE I (Paris: Plon, 1958), 38: "'La barbe,' le 'divin' oncle, que de suggestions ces termes n'apportent-ils pas au sociologue' — bring to the mind of the sociologist."

4 Philip S. Foner, THE GREAT LABOR UPRISING OF 1877 (New York: Monad Press, 1977).

5 Daisy Sewid-Smith, PROSECUTION OR PERSECUTION (s.l.: Nu-YumBaleess Society, 1979), 2–3.

6 Marshall Sahlins, CULTURE AND PRACTICAL REASON (Chicago: University of Chicago Press, 1976).

TRANSLATED FROM FRENCH BY FRANCINE DAGENAIS. A LONGER VERSION OF THIS ESSAY FIRST APPEARED IN PARACHUTE 55 (DECEMBER/JANUARY/FEBRUARY 1988/89). TRANSLATED AND REPRINTED WITH PERMISSION.

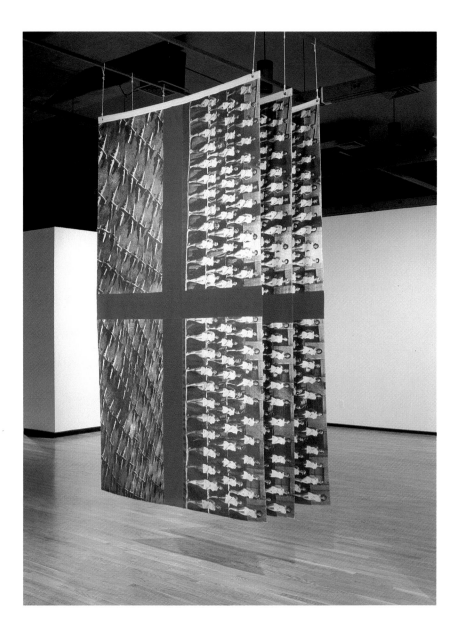

STARS AND STRIPES, 1985. 3 banners, silkscreen on fabric, 3 m x 1.7 m each. Collection: The Banff Centre.

Courtesy: Walter Phillips Gallery, Banff, Alberta. Photo: Monte Greenshields

112

Stars and Stripes of Dominique Blain: The Scarred Banner

Johanne Lamoureux

In 1985, when Dominique Blain's *Stars and Stripes* appeared in the *Écrans politiques* exhibition organized by France Gascon for the Musée d'art contemporain de Montréal, René Payant underscored the complexity of the pieces: "I believe that this work has to do not with ambivalence or polysemy but, rather, with a complexity sustaining an equivocable quality which calls upon the viewer not for resolution but for adaptation to its own terms."[1] Payant's interest in this series is clearer when one considers the following comment he made with respect to one of the artist's first shows:

> It is not a matter of soliciting a "political theory" from art, but of requiring that, as art, it probe into, work out a new (postmodern?) concept of, the political. In other words: a questioning of politics in art terms.[2]

It is debatable whether Blain's work since then has consistently sought inscription under the seal of complexity. In a number of more recent works, the chain of signifieds (Gothic stained-glass window, missile, shell) triggered by a single form (the *ogive*[3]) deliberately imposes a simple rhetoric on viewers, one wherein meaning is overdetermined. But since Blain's point of departure is located in a questionable political order, and not in its typical manifestations, one could say that the deployment of rhetoric and the ensuing situation of the viewer are often more significant than the themes or images used.

113

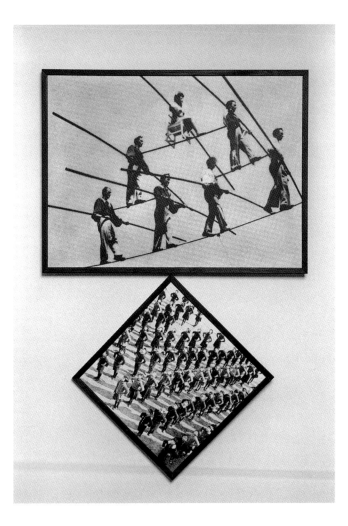

EARTHLINGS, 1985. Emulsion on film, wood, 1.22 m x 91 cm. Collection:

Canada Council Art Bank, Ottawa, Ontario. Courtesy: the artist.

Photo: Pierre Zabbal

The medium of *Stars and Stripes* is not photography. But its silkscreens do use photographic raw material, along with one of the most politically resonant of photographic strategies – photomontage. I am warranted, I believe (notwithstanding the photographic pretext of this anthology) in looking at this series in terms of format, instead of photography. Dominique Blain has consistently demonstrated acute intelligence both in the choice of formats for her work and in the ways in which these are handled. It is, generally, through these that she registers the contextual specificity of her work in exhibitions, unlike other artists who often rely on theme or the contingencies of placement in exhibition spaces.

Thus, in the Musée du Québec's 1989 exhibition, *Territoires d'artistes: Paysages verticaux*,[4] Blain was alone in opting for the billboard format as a way of assuming her place in the urban context. For the *Fictions*[5] exhibition, whose pieces employed camouflaging strategies to blend into the environment of Mirabel airport, Blain had paper bags printed with the silhouette of a third world figure, a woman carrying an object on her head. Encumbered travellers who bought one of these bags to hold their own pile of foreign commodities often unwittingly played out a *mise en abîme*[6] that was programmed into the very concept of the object, a strategy that, via the repeated motif of the porter, deployed its ironic effects.

In *Stars and Stripes,* Blain employs the political format of the banner – the emblematic prop of demonstrations, lobbies, opposition movements. This was evident from the recent inclusion of other works from this series in the exhibition, *Un archipel de désirs*.[7] Unstretched canvases were placed perpendicularly against the wall and hung close together from the ceiling like so many standards. Yet the title left no doubt that this political format, by definition entirely void of content, was being played off against a specific political referent – the American flag. Through this collusion, Blain set out to enact her "questioning of politics in art terms."

Given artists' current interest in the questions of identity and nationalism in the postcolonial and post-hegemonic context, Dominique Blain's series falls within the ambit of postmodernism. I would like, however, to examine the way she reformulates the issues raised by one of the most emblematic pieces of American modernism – Jasper

DUTY FREE, 1990. Silkscreen on paper bag, 60 cm x 40 cm x 15 cm. Collection: the artist.

Courtesy: the artist

Johns' *Flag*, a painting that, for Johns, became the point of departure for a series of variations.

Johns claims to have come up with the motif of the American flag while looking for images that would already be familiar to viewers ("things the mind already knows").[8] This explanation, which appears somewhat provocative, does not explain why Johns initially chose to have the frame of his painting coincide with the flag motif, why he made the relationship between the object-painting and the flag-image a focus of reflection.[9] Certainly, by adopting this motif, Johns picked up a pattern that freed him from compositional constraints without throwing him back upon a seamless configuration. Yet Johns would go on to attend to this found icon, this untouchable object, through a veil of brushwork, overlaying the motif with a gestural, all-over treatment that, as Payant so succinctly put it, cooled down the gestural quality of the action painters and inflected it in the direction of constructive gesturalism. Johns simultaneously articulated an iconic motif (the flag) and a pictorial one (the all-over treatment), refusing to see in either anything beyond a pure signifier unburdened of all signifieds. He thereby shifted the question of the iconography of paintings, apparently revived in this work, toward the process of their making.

Dominique Blain's series demonstrates little interest in the relationship of flag and painting. The title's allusion to the American flag is less a direct quotation than a way of underscoring a certain Americanness in the relationship to the flag, that is, an exemplary symbolic relationship, intense and paradoxical, between Americans and their spangled banner. Blain does not borrow the pattern of the American flag, preferring instead a cruciform, more egalitarian composition. This is because her work calls up the flag-object more so than the flag-image. She does not approach the flag as a two-dimensional, disembodied motif indiscriminately stamped on commodities, reproduced in dyed carnations for the Rose Bowl parade, or hoisted above a building. Her articulation of flag and banner points to a situation of the object. It is less a question of "things the mind already knows," of a mundane image that might serve as a bridge to another level of analysis, than of an object that, invested with specific values, is both the source and target of certain practices – an object that is run up a flagpole or flown

SANS TITRE, 1989. Silkscreen transfer on wood panel, 3.1 m x 6.1 m. Collection: the artist. Courtesy: the artist.

Photo: Patrick Altman

118

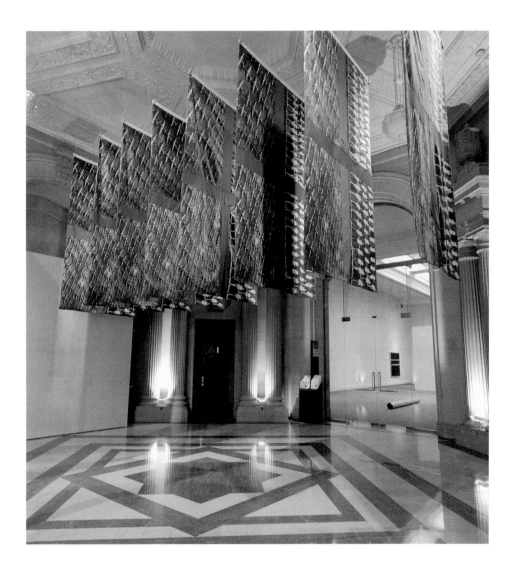

STARS AND STRIPES (installation view), 1985. Silkscreen on fabric. Collection: various.

Courtesy: the artist. Photo: Patrick Altman

119

at half-mast, that one waves or burns. It is an oxymoronic object that simultaneously embodies the abstract and regulating power of the State (marking the site of its operations and emissions) and supposedly symbolizes the elevation of the rights of the individual and freedom of expression.

Such contextualization makes it abundantly clear why photography and photomontage are used in this series. The conjoining of flag and photography is just as sacrilegious as the fabrication of Johns' *Flag.* A figurative crime has taken place. This accolade cracks the narrow code of national pennants, breaks with their restricted range of saturated colours and their repository of acceptable motifs. It flouts the conventional abstraction of flags which, even when they include figurative elements, do so in a way that is stylized, schematic and, above all, symbolic.

The black and white of photography replace the loud colours and heraldic schematization of flags with a colourless, anonymous form of figuration. Blain uses this to attack the customary semiotic register of the national ensign which, according to semiologist C.S. Pierce's typology of the sign, falls under the category of the symbol. For, even if the photographic image can always function as a symbol (as photomontage has amply demonstrated), it partakes primarily of the semiotics of the index through the initial physical contiguity of apparatus and referent, and possesses an analogical quality that likens it to the icon. In addition, the use of *Life* magazine photographs complete with dates opens a temporal, chronological dimension at the heart of the floating, temporal imagery of national banners.

The choice of photographs was anything but haphazard. For example, the same motifs – the human body made taut by exercise, the combat aircraft – are repeated. The latter echoes, in its morphology, the stars that on the American flag represent the different states in the union. But beyond this metaphoric operation, activated through formal rhyme, it is the composition of the found and reframed images that is most important here. Airplanes and young women are aligned together. There is not a thing out of place. Ordered, these motifs are part, nonetheless, of a single mass composed of infinite repetitions. The *all-over* treatment quells every trace of heroism, every singularity of action, reducing the performance to a well-managed squadron

manoeuvre. Combined with each motif singly, and with the dynamics of their interaction, the standardizing effect of the *all-over* treatment is further reinforced by the cruciform structure of the image, which is cut by red stripes into four equal rectangles. The *all-over* treatment, applied here to borrowed and even banal imagery, exhibits the standardization of bodies and behaviour. The result is an approximate American flag which, instead of exalting freedom of expression, is presented (betrayed somewhat by the all American all-over ethos) as the standard of standardization.

As in *Flag,* the *all-over* effect and the flag are articulated in *Stars and Stripes* but Blain's questioning of these pictorial and iconic motifs in art terms modulates and exposes the ideological values already at work in matter and form. Some people burn flags, others redraw them. The figurative action may be no less powerful.

NOTES

1 René Payant, "Écrans politiques," PARACHUTE 42 (March/April/May 1986), 47–48. Also see the introduction to the catalogue: FRANCE GASCON: ÉCRANS POLITIQUES (Montréal: Musée d'art contemporain de Montréal, 1985).

2 Payant, "Dérives: Michel Gaboury, Dominique Blain, Renée Désilets," VEDUTE: PIÈCES DÉTACHÉES SUR L'ART 1976–1987, preface by Louis Marin (Laval: Éditions Trois, 1987), 529.

3 Translator's note: In French, *ogive* can mean either a Gothic arch or a warhead.

4 Louise Déry, TERRITOIRES D'ARTISTES: PAYSAGES VERTICAUX, 2 vols. (Québec: Musée du Québec,1989).

5 Jérôme Sans, FICTIONS (Montréal: Les Grands Espaces and Galerie Aubes 3935, 1989).

6 Translator's note: A term deriving originally from heraldry, where it referred to the mirror effect created by surrounding the coat of arms with a border that reproduced the contours of the shield. It is used generally in semiotics to indicate the use of an element within a work to reproduce, in miniature, the overall or essential structure of the work in which it is found. Marc Angenot, GLOSSAIRE PRATIQUE DE LA CRITIQUE CONTEMPORAINE (Hurtubise HMH: Ville LaSalle, 1979).

7 Louise Déry, UN ARCHIPEL DE DÉSIRS: LES ARTISTES DU QUÉBEC ET LA SCÈNE INTERNATIONALE (Québec: Musée du Québec, 1991).

8 Harold Rosenberg, "Jasper Johns: Things the Mind Already Knows," THE ANXIOUS OBJECT (New York: Collier Books, 1966), 177—184.

9 Payant, "De l'iconologie revisitée," VEDUTE, 31—49.

TRANSLATED FROM FRENCH BY DON MCGRATH.

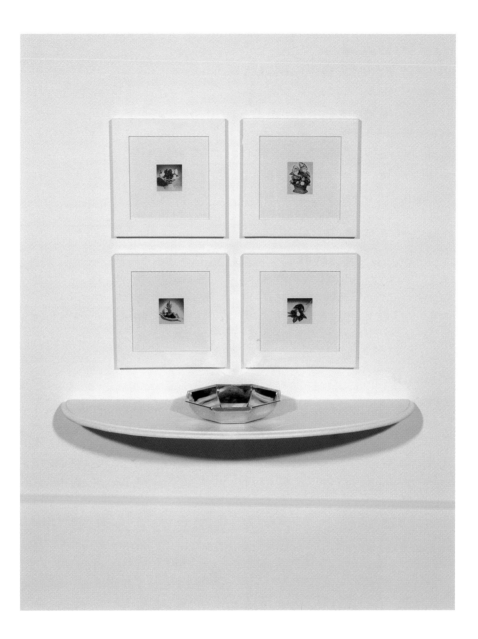

TASTE, 1988. 4 black and white silver prints, sterling silver bowl, painted shelf; prints: 36 cm x 36 cm

each; shelf: 2.5 cm x 1.11 m x 38 cm. Collection: The Banff Centre. Courtesy: Walter Phillips Gallery,

Banff, Alberta. Photo: Monte Greenshields

A History of Manners:
Susan Schelle's TASTE

Ian Carr-Harris

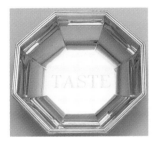

In patriarchal societies we cannot escape the implications of femininity. Everything we do signifies compliance or resistance to dominant norms of what it is to be a woman.[1]

Chris Weedon

The effect is to highlight, or "highlight," and to subvert, or "subvert," and the mode is therefore a "knowing" and an ironic or even "ironic" — one. Postmodernism's distinctive character lies in this kind of wholesale "nudging" commitment to doubleness, or duplicity.[2]

TASTE (detail) 1988.

Photo: Monte Greenshields

Linda Hutcheon

I am interested in the manipulation of the common. This often involves the use of imagery that deals with the phenomena of the physical world and the customs of a particular time or people.[3]

Susan Schelle

In 1983, Susan Schelle exhibited a work she titled *Talking and Listening to the Man in the Moon*. In reviewing that work, I criticized her for taking an isolationist position which I felt evaded the necessity to take issue. I now think that we were both right: it *is* necessary to take issue; and Susan Schelle *did*. What I failed to understand then was that in our culture "talking and listening to the Man in the Moon" is not a retreat so much as an apt description of the experience of women within male culture. How can one characterize the consequences of this condition if not as living in some kind of "midsummer night's dream," the source of Schelle's title? Very simply, her work described that condition.

It is useful to bear this digression in mind as an approach to Schelle's 1988 work, *Taste*. The work is straightforward: four small photographs, square-framed in white with broad mats, are organized to form a larger square directly above an elegant semicircular white shelf with molded edges. On this shelf is placed an octagonal silver bowl, shallow enough to be ambiguous in function, on whose interior surface is engraved the single word "taste." The photographs are clearly of illustrations from a magazine dating, perhaps, from the 1940s or 1950s; together they demonstrate fruit arrangement in four traditional and quite unambiguous styles of bowl – a cornucopia, a basket, a compote and a boat. Everything is precise, attractive – polite, one might say. Even the rather unusual word inscribed on the silver bowl is easily explained as an amusing *double entendre* linking fruit and bowl. There appears to be no overt "problem" – no threat of unpleasantness. And yet...why is the word "taste" inscribed so meticulously on that bowl? *Why* are the photographs so small within their gigantic white mats? *Why* this inscrutable politeness?

It is this very sense of unease, of latent "duplicity," that Hutcheon and others have located as a central agent in contemporary thought, and in postmodern critiques of the subject. For both men and women – though for polarized reasons – unease has a long history. As Weedon says, everything a woman does, or has ever done, within patriarchal culture will inevitably signify compliance or resistance, and at the root of male hostility towards women and female culture there surely lies a nudging suspicion that compliance – or even complicity – remains circumstantial. I want to explore briefly *how* Schelle's work describes a condition of duplicity centrally fatal to patriarchy itself, how

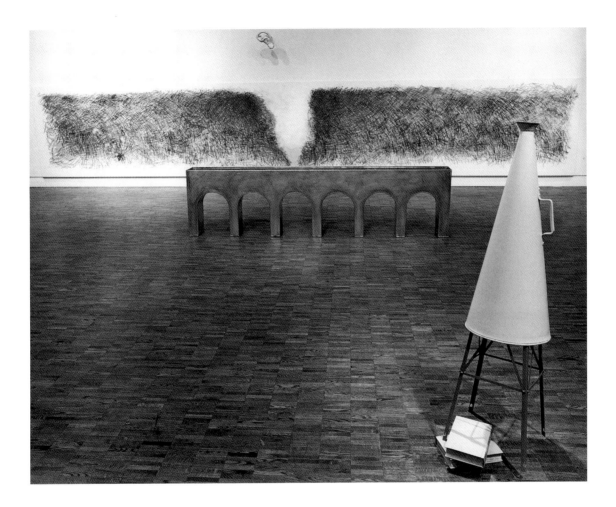

TALKING AND LISTENING TO THE MAN IN THE MOON, 1983. Clay, plywood, graphite, paint, sheet metal, steel

books, 7.32 m x 6.1 m x 3 m. Collection: the artist. Courtesy: the artist. Photo: Susan Schelle

it in fact *exacerbates* this condition in a way that perhaps the earlier work did not, in order to demonstrate a critical disengagement; and it seems useful to pivot this exploration on the title's own play of meaning.

Any "manipulation of the common" de-cloaks the investments of authority – the common-sense assumptions negotiated by generations before us on our behalf. As such, it is a means of unravelling history. In *Taste,* Schelle addresses the history of manners and expectations which, while binding on both men and women, have traditionally bound women most fatally. This is a history of agreements whose fragility and self-contradictions have been, for women, tantamount to a profound disguise. It is worth noting this because the obvious *double entendre* in the title is a mocking form of such disguise: we are not likely to be fooled by the reference to fruit; we know that the work is about style, even if we do not quite know why. But the why is not so hard for those who know its effects: it is the *form of the obligation itself* – the imposition of disguise – which is at issue. In *Taste,* the various containers – those in the photographs and, in a radically different way, the silver bowl as well – carry a history of subjugation – the subjugation of use to ornament, of women's work to "lady-like" behaviour and of experience to language. It is important to examine just how the elements of the work function *against taste.*

The question of taste is pre-eminently a question of behaviour and Schelle's choices explicitly link the question of behaviour to bourgeois culture. She is herself conscious of being a product of a certain privileged class located in a certain privileged place: Ontario white, Anglo-Saxon middle class. For this class, manners and obligations reflect the constrictions of a patriarchal society in power; signs and codes do not slide too easily and ornaments, even inessential ones, are expected to keep their place. It is a culture of extreme stability, of stasis; it is a culture in which uneasiness is inescapable and one that Schelle can speak from with confidence.

But the linkage has more than personal significance: bourgeois taste has legislated modern culture since the French Revolution. While class-constructed, it is not class-bound: it operates for us as normative, as common sense, and Schelle's work reads like a catalogue introduction to the culture of conformity *as it confronts women.* In one important respect women "do not fit" within bourgeois values: for a system built on the

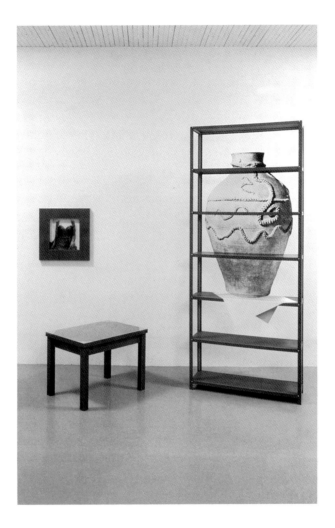

PASSIVE POWERS, 1989. Wood, sandblasted glass, masonite, paint,
line negatives, 2.74 m x 1.22 m x 2.13 m. Collection: Art Gallery of Hamilton,
Ontario. Courtesy: Art Gallery of Hamilton, Ontario. Photo: Peter MacCallum

ethic of work, on labour exchange (or labour exploitation), women's exclusion from work, their seclusion as ornament, places them outside the ethical system. Though women were excluded in important ways before the rise of middle-class culture, exclusion from work within a work ethic system amounts to exile. This marginalization finds historical expression in the greater importance given to "art" over "craft" such as embroidery and, within art, the long-standing privilege of history painting – the preserve of male artists – over so-called "genre" paintings of fruit – to which women artists were traditionally relegated and to which, despite shifts in theory, women in general are still. It is by no means incidental that Schelle has chosen fruit arrangements as emblems of exclusion, an exclusion further dramatized by the miniature scale of the photographs, their grainy, borrowed character, and by the vastness of their blank surrounding borders. Nor is it simply incidental that these arrangements are presented as impoverished versions of a distant original. Lacking "aura," lacking the stamp of presence, they remain for us remote in time and place; they remain in an important sense *irrelevant*.

In stark contrast to this plane of dismissal, presence is inherent in the shelf and its ambiguous flat silver bowl. Sheer physical presence is significant enough but in middle-class culture, with its dependency upon writing, on the whole apparatus of bureaucracy, there is, after all, something useful, even *natural,* about things on flat surfaces, just as there is something useless, even *unnatural,* about things that are hung. Positioned on the firm ground of a surface to which things cling, the bowl registers an authority which divides this work at the line between shelf and pictures, a line that signals a paradigm shift from the female exclusions on the wall to the confident assumptions of male power below. As I suggested earlier, the bowl's very ambiguity serves to position it in a radically different role from those in the photographs. Unlike the ornamental fruit bowls, with their specifically designed and gender-inflected function, the silver bowl lacks any single purpose: it is a designed *object,* independent of any "natural" purpose. It belongs, in fact, to an abstract order of representations whose sole metaphoric function is to signal control. In referencing, but not being, an ornamental use-object, in remaining both physically and formally independent, it acts like the linguistic sign engraved on its surface to mark both a distant association and a radical rupture with

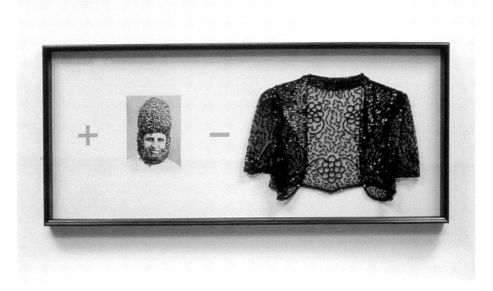

HAUTE COUTURE, 1990. Photograph, brass, sequins, 56 cm x 1.32 m x 8 cm. Collection: the

artist. Courtesy: the artist. Photo: Peter MacCallum

the world represented in the photographs. In substituting language – the word "taste" – for depiction, the bowl operates against the photographs of fruit as sign to its referent, though the photographs operate on their own as signs of exclusion. In *displacing* the photographs as signs, in effect emptying them of signification, the bowl unmistakably acts to privilege culture over nature, to flaunt male power and to signal female banishment.

Taste would be an interesting work for its exacerbated portrait of simulated compliance alone. However, as I have mentioned, the title permits another reading of the shift line described above which allows a different, more active and transgressive view of the exclusions in operation. It is true, after all, that good taste bears a substantive relationship to "tastes good," even if it is a relationship denied by its cultural alter ego. Underlying the text, underlying its abstraction, its decorousness, there lurks its banished "other" – the *referent* which refuses to be merely an abstraction, which claims sensual gratification. There is, in fact, an ironic dimension to the sequestering of the word "taste" in its simple, geometrically correct silver bowl from the fruits in their complex, flowing containers locked away in "the world of women." It is an irony which, on the theoretical plane, has been described by Andreas Huyssen as a *complicity* tacitly acknowledged in bourgeois modernity's hierarchical privileging of high art over mass culture, a complicity complicated by a historical identification of mass culture with women, or more precisely the *threat of Woman as consuming Nature,* on the one hand, and of high culture with male rationality and *cultural control* on the other. In other words, despite its claims to exclusive authenticity, the male-inflected linguistic sign of *Taste* acknowledges, as it fears, its banished life form, just as it acknowledges, and fears, the power it has consequently invested in women. With such a reading, this ironic *pas de deux* within the title becomes inevitably the central dialectic, or perhaps more aptly, the Derridean *erasure,* of Schelle's work.

In raising the problem of modernity's collusions with its own excluded partners, *Taste* embraces a discussion central to contemporary art practices and theory. This discussion has notably been advanced through a realization that photographic practices in particular, including the history of film, are ideally located to offer the betrayals through which we can see what we have to say. The discussion consequently has a

strong archaeological methodology and Schelle's work, with its precise and targeted investigation of pre-existing representations, offers us a perfect example of this determination that discovering meaning, like digging for gold, is less invention than close examination.

NOTES

1 Chris Weedon, FEMINIST PRACTICE AND POSTSTRUCTURALIST THEORY (Oxford: Blackwell, 1988), 86-87.

2 Linda Hutcheon, THE POLITICS OF POSTMODERNISM (London: Routledge, 1989), 1.

3 Susan Schelle, SANS DEMARCATION (Toronto: Visual Arts Ontario, 1987), 28.

Contributors

SHELAGH ALEXANDER is an artist living in Toronto. She was born in Winnipeg, Manitoba, and studied fine arts at York University in 1977 and 1978. In 1981, she graduated from the Ontario College of Art. She was a co-founder of Grace Hopper Artists' Collective in Toronto. Her work has been exhibited across Canada and internationally, including an exhibition at the Institute for Contemporary Art in London and the Canadian Biennial of Contemporary Art at the National Gallery of Canada in 1989.

RAYMONDE APRIL is an artist living in Montreal. She was born in Moncton, New Brunswick, and attended art college at Rivière-du-Loup and l'Université Laval in Quebec. She is a co-founder of La Chambre Blanche, an artist-run centre in Quebec City. Her work has been exhibited across Canada and in Europe, including the Musée d'art contemporain de Montréal and Espace Colbert at the Bibliothèque Nationale in Paris. Until 1986, she taught part-time in the department of visual arts at the University of Ottawa and now teaches photography at Concordia University.

ROY ARDEN is a Vancouver-based artist whose work has been exhibited across Canada, the United States and Europe, including the Galerie Giovanna Minelli in Paris and the Museum of Traditional Values in New York. He was born in Vancouver, graduated from Emily Carr College of Art and Design in 1982 and completed a masters of fine arts degree at the University of British Columbia in 1990. His work belongs in numerous public collections in Canada and Europe, including the Staatsgalerie in Stuttgart and the Art Gallery of Ontario.

DAINA AUGAITIS is a curator working as Director of Visual Arts at the Banff Centre for the Arts and Chief Curator of the Walter Phillips Gallery.

RICHARD BAILLARGEON is an artist and writer born in Lévis, Quebec. He completed a master of arts degree in anthropology at l'Université Laval in 1978. In 1987, he was the first Canadian photographer to be awarded the Duke and Duchess of York Award in Photography by the Canada Council. His work has been exhibited in numerous group and solo shows in Quebec, Canada and abroad. He is a founding member of VU, an artist-run centre in Quebec City where he has curated exhibitions. Since 1990, he has been program director of photography at the Banff Centre for the Arts.

SERGE BÉRARD was born in Montreal and currently lives in Vancouver. He has been an art critic for the past fifteen years and is currently completing his doctorate in fine arts at the University of British Columbia.

DOMINIQUE BLAIN is an artist born in Montreal who currently lives in Los Angeles and Montreal. She received a bachelor of fine arts degree from Concordia University and is a founding member of Articule in Montreal. Her work has been exhibited in Canada, the United States and Europe, including Les cents jours d'art contemporain at the Centre International d'Art Contemporain de Montréal and the Sydney Biennial in 1992, and belongs in numerous public collections.

JAMES D. CAMPBELL is an independent curator and art writer living in Montreal who has published numerous monographs, essays and reviews. Recently curated exhibitions, which were accompanied by catalogues, include RON MARTIN, THE GEOMETRIC PAINTING: 1981-1985 and MURRAY FAVRO: THE GUITARS 1966-1989 at the Mackenzie Art Gallery in Regina, and ABSTRACT PRACTICES II at The Power Plant in Toronto. He also lectures on photography and contemporary art and is a regular contributor to art periodicals such as C MAGAZINE.

KATI CAMPBELL is an artist whose work has been exhibited across Canada and in Europe. She was born in Ontario and briefly attended the Ontario College of Art. In 1984 she completed a bachelor of arts degree in interdisciplinary studies from Simon Fraser University and received her master of arts degree in art history from Leeds University in England in 1991. She lives in Vancouver where she co-founded in 1986 the Vancouver Association for Noncommercial Culture, an artist collective that mounts public projects. Her work belongs in a number of public collections.

IAN CARR-HARRIS is a Toronto artist with an extensive exhibition history in Canada and Europe. His work is included in the collections of the National Gallery and the Art Gallery of Ontario among others. He is chair of the sculpture/installation program and an instructor in contemporary art theory at the Ontario College of Art, and has for many years contributed articles and reviews on Canadian art to PARACHUTE, VANGUARD and C MAGAZINE.

EVERGON is an artist born in Niagara Falls, Ontario. He received a bachelor of fine arts degree from Mount Allison University in Sackville, New Brunswick, in 1970 and a master of fine arts from the Rochester Institute of Technology in 1974. Since then, he has been teaching photography, drawing and design in the visual arts department of the University of Ottawa. His work has been exhibited extensively throughout North America and abroad and is in numerous public collections.

CHARLOTTE TOWNSEND-GAULT is a writer, critic and co-curator who lives on Bowen Island, British Columbia. She has written extensively on photographic practices and other aspects of contemporary art for catalogues and periodicals published across Canada. She was co-curator of the LAND, SPIRIT, POWER FIRST NATIONS AT THE NATIONAL GALLERY OF CANADA in 1992. Currently she is preparing her doctoral dissertation in social anthropology for publication.

ALAIN LAFRAMBOISE is an artist whose work has been exhibited in Canada, Switzerland and Italy and belongs in the collections of the Canada Council Art Bank, Musée d'art contemporain de Montréal and the Musée du Québec. He teaches art history and theory at l'Université de Montréal, specializing in Italian mannerism, and is author of ISTORIA ET THÉORIE DE L'ART, ITALIE XV°−XVI°S. He is a regular contributor to numerous periodicals on contemporary art including PARACHUTE, VANGUARD and PROTÉ and is co-founder and co-director of the journal ÉDITIONS TROIS.

JOHANNE LAMOUREUX is a writer, critic and art historian who lives in Montreal. She received her doctorate in art history in 1990 and has since been an assistant professor in the art history department at l'Université de Montréal. A founding member of La société d'esthétique du Québec, she has acted on the board of several periodicals and is a regular contributor to exhibition catalogues and art journals such as PARACHUTE and ÉDITIONS TROIS.

MARK LEWIS is an artist whose work has been exhibited in Canada, the United States and Europe, including the Institute for Contemporary Art in London and P.S. 1 in New York. He currently lives in Vancouver where he teaches in the fine arts program at the University of British Columbia. He is a founding member of Public Access, a writer and artist collective in Toronto and is co-editor of PUBLIC, an art and theory journal. He is also completing a film.

SUSAN McEACHERN is an artist who teaches photography at the Nova Scotia College of Art and Design in Halifax, Nova Scotia. In 1988, she completed a master of arts degree in sociology of education with an emphasis on feminist studies and gender relations at the Ontario Institute for Studies in Education (O.I.S.E.) at the University of Toronto. She is active in the women's and peace movements and has exhibited and lectured widely in Canada and the United States.

SUSAN SCHELLE is an artist living in Toronto. Her work has been shown nationally and internationally, and is included in the collections of the Winnipeg Art Gallery, Art Gallery of Hamilton and the Canada Council Art Bank. She is a founding member of the Cold City Gallery collective and has served on the board of Mercer Union and the Toronto Sculpture Garden. She has worked on numerous public commissions including SALMON RUN at the Toronto Skydome and is working on a site-related work for the science complex at York University.

CHERYL SIMON is a photographer, writer and curator currently living in Montreal. Her writings on photography have appeared in periodicals including VANGUARD, PHOTO COMMUNIQUE, VIEWS and CANADIAN ART, as well as a variety of exhibition catalogues and special publications. In 1989 she curated an exhibition of contemporary Canadian photography entitled THE ZONE OF CONVENTIONAL PRACTICE AND OTHER REAL STORIES and edited a book by the same name.

ABIGAIL SOLOMON-GODEAU is an art and photography critic, an occasional curator and an art historian specializing in nineteenth-century French art. She is currently a visiting professor in the department of art history at the University of California, Santa Barbara. Her essays have appeared in such periodicals as AFTERIMAGE, ART IN AMERICA, CAMERA OBSCURA, OCTOBER and SCREEN EDUCATION. A book of her selected essays, PHOTOGRAPHY AT THE DOCK: ESSAYS ON PHOTOGRAPHIC HISTORY, INSTITUTIONS AND PRACTICES, was published in 1991 by the University of Minnesota Press. She is currently completing a book entitled THE IMAGE OF DESIRE: SEXUALITY, FEMININITY AND PHOTOGRAPHY IN NINETEENTH-CENTURY FRANCE.

IAN WALLACE is an artist born in Shoreham, England, who has lived in Canada since 1944. In 1952, he moved to Vancouver where he studied at the University of British Columbia, receiving a bachelor of arts degree in art history in 1966 and a master of arts in art history in 1968. His work is shown extensively in Europe, where he is represented by several galleries, and throughout North America. He lives in Vancouver where he teaches at the Emily Carr College of Art and Design.

SCOTT WATSON is a Vancouver art historian, critic, curator and writer who has contributed to numerous international art-related publications. His most recent book, entitled JACK SHADBOLT, was published in 1990 by Douglas and McIntyre. Prior to his current position as director/curator at the University of British Columbia Fine Arts Gallery, he was curator at the Vancouver Art Gallery.

DONNA ZAPF is a Vancouver writer and musician. Over the past decade she has produced and performed contemporary music and has written about contemporary music and the visual arts in Canada. She teaches music and critical studies in the arts at the School for the Contemporary Arts at Simon Fraser University.